EMPTY WORDS

Hartley
RD Laing KNOTS

E M P T Y
W O R D S

Writings '73–'78 by John Cage

WESLEYAN UNIVERSITY PRESS
Middletown, Connecticut

Published by
Wesleyan University Press
Middletown, CT 06459

First paperback edition 1981
Printed in the United States of America 5

Most of the material in this volume has previously appeared elsewhere.

"Preface to: 'Lecture on the Weather' " was published and copyright © 1976 by Henmar Press, Inc., 373 Park Avenue South, New York, New York 10016. Reprint permission granted by the publisher.

An earlier version of "How the Piano Came to be Prepared" was originally the Introduction to *The Well-Prepared Piano,* copyright © 1973 by Richard Bunger. Reprinted by permission of the author. Revised version copyright © 1979 by John Cage.

"Empty Words" Part I copyright © 1974 by John Cage. Originally appeared in *Active Anthology.* Part II copyright © 1974 by John Cage. Originally appeared in *Interstate 2.* Part III copyright © 1975 by John Cage. Originally appeared in *Big Deal.* Part IV copyright © 1975 by John Cage. Originally appeared in *WCH WAY.*

"Series re Morris Graves" copyright © 1974 by John Cage. See headnote for other information.

"Where are We Eating? and What are We Eating? (Thirty-eight Variations on a Theme by Alison Knowles)" from *Merce Cunningham,* edited and with photographs and an introduction by James Klosty. Copyright © 1975 by James Klosty. Reprinted by permission of E. P. Dutton/Saturday Review Press.

"Writing for the Second Time through Finnegans Wake" copyright © 1978 by John Cage. The original text on which this text is based is *Finnegans Wake* by James Joyce, copyright © 1939 by James Joyce, © renewed 1967 by George Joyce and Lucia Joyce. This text is used by kind permission of the Society of Authors, London.

"The Future of Music" copyright © 1974 by John Cage. Originally appeared in *Numus West.* Revised version copyright © 1979 by John Cage.

Mesostics:
"A Long Letter" copyright © 1977 by John Cage. Originally appeared in *Selected Studies for Player Piano* by Conlon Nancarrow.

" 'I'm the happiest person I know' " was published in the *Minneapolis Star,* April 3, 1975. Reprinted by permission of the *Minneapolis Star.* Copyright © 1975 by John Cage.

Library of Congress Cataloging in Publication Data

Cage, John.
 Empty words.

 1. Music—Addresses, essays, lectures. 2. Music—
History and criticism—20th century. I. Title.
ML60.C12 780'.8 78-27212
ISBN 0-8195-6067-7

To the students in the school
from which we'll never graduate

Contents

Recently I was a houseguest in Paris. At breakfast I was talking with another guest in the same home, a lady from Australia. In response to a newsreport, I said, "Why? Why did it happen?" The lady from Melbourne said, "That is a question for which there is no longer an answer."

I am an optimist. That is my raison d'être. But by the news each day I've been in a sense made dumb. In 1973 I began another installment of my *Diary: How to Improve the World (You Will Only Make Matters Worse)*: it remains unfinished.

Foreword

Buckminster Fuller too from prophet of Utopia has changed to Jeremiah. He now gives us eight to ten years to make essential changes in human behaviour.

Perhaps all of us are needlessly shocked and alarmed. A subtle but radical change may be taking place which only superficially deprives us of our wits, which fundamentally is altering for the good mankind's condition. Let us hope so. Wishful thinking?

EMPTY WORDS

When in 1975 Richard Coulter of the Canadian Broadcasting Corporation offered me a commission to write a piece of music to celebrate the American Bicentennial, I automatically accepted because the invitation came from outside the United States. He suggested that I base it on texts of Benjamin Franklin. I got a copy of *Poor Richard's Almanac* but shortly put it aside, returning to the writings of Thoreau, the *Essay on Civil Disobedience*, the *Journal*, and *Walden*.

[Recently, in the course of preparing a European tour, June 1978, with Grete Sultan and Paul Zukofsky, during which I would sometimes read an excerpt from *Empty Words* Part III, I found that an otherwise cultivated Swiss thought Thoreau was French, didn't know he was an American, let alone know anything about his work. I therefore wrote the following program note:

Henry David Thoreau (1817–1862) lived in Concord, Massachusetts. For two years he lived alone in the woods, two miles from town, by the side of Walden Pond. He built his

Preface to "Lecture on the Weather"

home and grew his food, and each Sunday walked back to Concord to have dinner with his mother and father and other relatives or friends. He is the inventor of the pencil (he was the first person to put a piece of lead down the center of a piece of wood). He wrote many books including a *Journal* of fourteen volumes (two million words). His *Essay on Civil Disobedience* inspired Gandhi in his work of changing India, and Martin Luther King, Jr., in his use of nonviolence as a means of revolution. No greater American has lived than Thoreau. Emerson called him a speaker and actor of the truth. Other great men have vision. Thoreau had none. Each day his eyes and ears were open and empty to see and hear the world he lived in. Music, he said, is continuous; only listening is intermittent. He did have a question: Is life worth living? *Walden* is his detailed and affirmative reply.]

Subjecting Thoreau's writings to *I Ching* chance operations to obtain collage texts, I prepared parts for twelve speaker-vocalists (or -instrumentalists), stating my preference that they be American men who had become Canadian citizens. Along with these parts go recordings by Maryanne Amacher of breeze, rain, and finally thunder and in the last (thunder) section a film by Luis Frangella representing lightning by means of briefly projected negatives of Thoreau's drawings. Before a performance of *Lecture on the Weather*, the following text is read as a Preface.

The first thing I thought of doing in relation to this work was to find an anthology of American aspirational thought and subject it to chance operations. I thought the resultant complex would help to change our present intellectual climate. I called up Dover and asked whether they published such an anthology. They didn't. I called a part of Columbia University concerned with American History and asked about aspirational thought. They knew nothing about it. I called the Information Desk of the New York Public Library at 42nd Street. The man who answered said: You may think I'm not serious, but I am; if you're interested in aspiration, go to the Children's Library on 52nd Street. I did. I found that anthologies for children are written by adults: they are

what adults think are good for children. The thickest one was edited by Commager (*Documents of American History*). It is a collection of legal judgments, presidential reports, congressional speeches. I began to realize that what is called balance between the branches of our government is not balance at all: all the branches of our government are occupied by lawyers.

Of all professions the law is the least concerned with aspiration. It is concerned with precedent, not with discovery, with what was witnessed at one time in one place, and not with vision and intuition. When the law is corrupt, it is corrupt because it concentrates its energy on protecting the rich from the poor. Justice is out of the question. That is why not only aspiration but intelligence (as in the work of Buckminster Fuller) and conscience (as in the thought of Thoreau) are missing in our leadership.

Our leaders are concerned with the energy crisis. They assure us they will find new sources of oil. Not only will Earth's reservoir of fossil fuels soon be exhausted: their continued use continues the ruin of the environment. Our leaders promise they will solve the unemployment problem: they will give everyone a job. It would be more in the spirit of Yankee ingenuity, more American, to find a way to get all the work done that needs to be done without anyone's lifting a finger. Our leaders are concerned with inflation and insufficient cash. Money, however, is credit, and credit is confidence. We have lost confidence in one another. We could regain it tomorrow by simply changing our minds.

Therefore, even though the occasion for this piece is the bicentennial of the U.S.A., I have chosen to work again with the writings of Henry David Thoreau. Those excerpts which are used were not selected to stress any particular points, but were obtained by means of *I Ching* chance operations from *Walden*, from the *Journal*, and from the *Essay on Civil Disobedience*. Thoreau lived not two hundred years ago but for forty-four years only beginning one hundred and fifty-nine years ago. In 1968 I wrote as follows: "Reading Thoreau's *Journal* I discover any idea I've ever had worth its salt." In 1862 Emerson wrote: "No truer American existed than Thoreau. If he brought you yesterday a new proposition, he would bring you today another not less revolutionary." In 1929 Gandhi wrote that he had found the *Essay on Civil Disobedience* so convincing and truthful that as a young man in South Africa preparing to devote his life to the liberation of India he had felt the need to know more of Thoreau, and so had studied the other writings. In 1958 Martin Luther King, Jr., wrote these words: "As I thought further I came to see that what we were really doing was withdrawing our cooperation from an evil system, rather than merely withdrawing our economic support from the bus company. The bus company, being an external expression of the system, would naturally suffer, but the basic aim was to refuse to cooperate with evil. At this point I began to think about Thoreau's *Essay on Civil Disobedience*. I remembered how, as a college student, I had been moved when I first read this work. I became convinced that what we were preparing to do in Montgomery was related to what Thoreau had expressed. We were simply saying to the white community, 'We can no longer lend our cooperation to an evil system.'"

On Dec. 8, 1859, Thoreau himself wrote as follows: "Two hundred years ago is about as great an antiquity as we can comprehend or often have to deal with. It is nearly

as good as two thousand to our imaginations. It carries us back to the days of aborigines and the Pilgrims; beyond the limits of oral testimony, to history which begins already to be enamelled with a gloss of fable, and we do not quite believe what we read; to a strange style of writing and spelling and of expression; to those ancestors whose names we do not know, and to whom we are related only as we are to the race generally. It is the age of our very oldest houses and cultivated trees. Nor is New England very peculiar in this. In England also, a house two hundred years old, especially if it be a wooden one, is pointed out as an interesting relic of the past."

I have wanted in this work to give another opportunity for us, whether of one nation or another, to examine again, as Thoreau continually did, ourselves, both as individuals and as members of society, and the world in which we live: whether it be Concord in Massachusetts or Discord in the World (as our nations apparently for their continuance, as though they were children playing games, prefer to have it).

It may seem to some that through the use of chance operations I run counter to the spirit of Thoreau (and '76, and revolution for that matter). The fifth paragraph of *Walden* speaks against blind obedience to a blundering oracle. However, chance operations are not mysterious sources of "the right answers." They are a means of locating a single one among a multiplicity of answers, and, at the same time, of freeing the ego from its taste and memory, its concern for profit and power, of silencing the ego so that the rest of the world has a chance to enter into the ego's own experience whether that be outside or inside.

I have given this work the proportions of my "silent piece" which I wrote in 1952 though I was already thinking of it earlier. When I was twelve I wrote a speech called *Other People Think* which proposed silence on the part of the U.S.A. as preliminary to the solution of its Latin American problems. Even then our industrialists thought of themselves as the owners of the world, of all of it, not just the part between Mexico and Canada. Now our government thinks of us also as the policemen of the world, no longer rich policemen, just poor ones, but nonetheless on the side of the Good and acting as though possessed of the Power.

The desire for the best and the most effective in connection with the highest profits and the greatest power led to the fall of nations before us: Rome, Britain, Hitler's Germany. Those were not chance operations. We would do well to give up the notion that we alone can keep the world in line, that only we can solve its problems.

More than anything else we need communion with everyone. Struggles for power have nothing to do with communion. Communion extends beyond borders: it is with one's enemies also. Thoreau said: "The best communion men have is in silence."

Our political structures no longer fit the circumstances of our lives. Outside the bankrupt cities we live in Megalopolis which has no geographical limits. Wilderness is global park. I dedicate this work to the U.S.A. that it may become just another part of the world, no more, no less.

Many Happy Returns

first the quaLity
 Of
 yoUr music

 tHen
 its quAntity
 and vaRiety
 make it Resemble
 a rIver in delta.
 liStening to it
 we becOme
 oceaN.

A Long Letter

 the musiC
 yOu make
 insN't
 Like
 any Other:
 thaNk you.

 oNce you
 sAid
 wheN you thought of
 musiC
 you Always
thought of youR own
 neveR
 Of anybody else's.
 that's hoW it happens.

The following text was written in 1972 as a foreword for Richard Bunger's *The Well-Prepared Piano*. It has been slightly changed for the present circumstance.

How the Piano Came to be Prepared

In the late 'thirties I was employed as accompanist for the classes in modern dance at the Cornish School in Seattle, Washington. These classes were taught by Bonnie Bird, who had been a member of Martha Graham's company. Among her pupils was an extraordinary dancer, Syvilla Fort, later an associate in New York City of Katherine Dunham. Three or four days before she was to perform her *Bacchanal*, Syvilla asked me to write music for it. I agreed.

At that time I had two ways of composing: for piano or orchestral instruments I wrote twelve-tone music (I had studied with Adolph Weiss and Arnold Schoenberg); I also wrote music for percussion ensembles: pieces for three, four, or six players.

The Cornish Theatre in which Syvilla Fort was to perform had no space in the wings. There was also no pit. There was, however, a piano at one side in front of the stage. I couldn't use percussion instruments for Syvilla's dance, though, suggesting Africa, they would have been suitable; they would have left too little room for her to perform. I was obliged to write a piano piece.

I spent a day or so conscientiously trying to find an African twelve-tone row. I had no luck. I decided that what was wrong was not me but the piano. I decided to change it.

Besides studying with Weiss and Schoenberg, I had also studied with Henry Cowell. I had often heard him play a grand piano, changing its sound by plucking and muting the strings with fingers and hands. I particularly loved to hear him play *The Banshee*. To do this, Henry Cowell first depressed the pedal with a wedge at the back (or asked an assistant, sometimes myself, to sit at the keyboard and hold the pedal down), and then, standing at the back of the piano, he produced the music by lengthwise friction on the bass strings with his fingers or fingernails, and by crosswise sweeping of the bass strings with the palms of his hands. In another piece he used a darning egg, moving it lengthwise along the strings while trilling, as I recall, on the keyboard; this produced a glissando of harmonics.

Having decided to change the sound of the piano in order to make a music suitable for Syvilla Fort's *Bacchanal*, I went to the kitchen, got a pie plate, brought it into the living room, and placed it on the piano strings. I played a few keys. The piano sounds

had been changed, but the pie plate bounced around due to the vibrations, and, after a while, some of the sounds that had been changed no longer were. I tried something smaller, nails between the strings. They slipped down between and lengthwise along the strings. It dawned on me that screws or bolts would stay in position. They did. And I was delighted to notice that by means of a single preparation two different sounds could be produced. One was resonant and open, the other was quiet and muted. The quiet one was heard whenever the soft pedal was used. I wrote the *Bacchanal* quickly and with the excitement continual discovery provided.

I did not immediately write another piece for the "prepared piano." It was later, in the early 'forties in New York City, due to the difficulties of organizing a percussion ensemble outside a school situation, that I began writing for a time almost exclusively for the prepared piano.

For Robert Fizdale and Arthur Gold I wrote two works for two prepared pianos, *Three Dances* and *A Book of Music*. These, together with *The Perilous Night* which I played, made a program at the New School in New York. There were five pianos on the stage, each prepared differently. There were only fifty people in the audience, but among them was Virgil Thomson, who wrote a review for the *Herald Tribune* which was enthusiastic about both the music and the performances. It was the first performance anywhere by Fizdale and Gold. I later revised the *Three Dances* for Maro Ajemian and William Masselos.

It was in the late 'forties while writing the *Concerto for Prepared Piano and Chamber Orchestra* that I received a telephone call from a pianist who had performed *The Perilous Night* on tour in South America. He asked me to come to his studio and hear him play. I did. His preparation of the piano was so poor that I wished at the time that I had never written the music.

Many years later while on tour in the southeastern U.S. with the Merce Cunningham Dance Company, Richard Bunger asked me to listen to his performance of *The Perilous Night*. I tried to get out of what I thought would be an ordeal. I said I was too busy. However, Richard Bunger persevered. When I finally heard him play, I was amazed to discover that he loved and understood the music and that he had prepared the piano beautifully.

When I first placed objects between piano strings, it was with the desire to possess sounds (to be able to repeat them). But, as the music left my home and went from piano to piano and from pianist to pianist, it became clear that not only are two pianists essentially different from one another, but two pianos are not the same either. Instead of the possibility of repetition, we are faced in life with the unique qualities and characteristics of each occasion.

The prepared piano, impressions I had from the work of artist friends, study of Zen Buddhism, ramblings in fields and forests looking for mushrooms, all led me to the enjoyment of things as they come, as they happen, rather than as they are possessed or kept or forced to be.

And so my work since the early 'fifties has been increasingly indeterminate. There are two prepared piano pieces of this character, *34'46.776" for a Pianist* and *31'57.9864"*

for a Pianist. They may be played alone or together and with or without parts *for a Stringplayer, a Percussionist,* and *a Speaker.* In these timelength piano pieces (or "whistle pieces" as David Tudor and I came to call them, since, to produce auxiliary noises called for in the scores, we had used whistles, our hands being busy at the keyboards) objects are added and subtracted from an initial piano preparation during the actual performance. The prepared piano now has a life of its own. A number of composers, both serious and popular, make use of it. Richard Bunger's inviting and encouraging manual, *The Well-Prepared Piano,* is available in both English and Japanese. The wish he expresses in it will certainly come true: many more discoveries by many more musicians.

S o n g

not Just
 gArdener:
morelS,
 coPrini,
morEls,
 copRini.

not Just hunter:
cutting dOwn
ailantHus,
 cuttiNg down
ailanthuS.

For S. Fort, Dancer

had there been two compoSers
 You
 might haVe asked the other one
 to wrIte your music.
i'm gLad
i was the onLy one
 Around.

Empty Words has four parts, each with an introductory text. Each has been published previously: Part I in George and Susan Quasha's *Active Anthology* 1974; Part II in *Interstate 2* (edited by Carl D. Clark and Loris Essary from Austin, Texas) 1974; Part III in Barbara Baracks' *Big Deal 3* (Spring 1975); and Part IV in *WCH WAY* (Fall 1975) edited by Jed Rasula.

Empty Words

Wendell Berry: passages outloud from Thoreau's *Journal* (Port Royal, Kentucky, 1967). *Realized I was starved for Thoreau (just as in '54 when I moved from New York City to Stony Point I had realized I was starved for nature: took to walking in the woods).* Agreed to write work for voices (*Song Books* [*Solos for Voice 3-92*]). Had written five words: "We connect Satie with Thoreau." Each solo belongs to one of four categories: 1) song; 2) song using electronics; 3) theatre; 4) theatre using electronics. Each is relevant or irrelevant to the subject, "We connect Satie with Thoreau." *Syntax: arrangement of the army (Norman Brown). Language free of syntax: demilitarization of language. James Joyce = new words; old syntax. Ancient Chinese? Full words: words free of specific function.* Noun is verbs is adjective, adverb. *What can be done with the English language? Use it as material. Material of five kinds: letters, syllables, words, phrases, sentences. A text for a song can be a vocalise: just letters. Can be just syllables, just words; just a string of phrases; sentences. Or combinations of letters and syllables (for example), letters and words, et cetera. There are 25 possible combinations.* Relate 64 (*I Ching*) to 25. *64 = any number larger or smaller than 64. 1-32 = 1; 33-64 = 2. 210 = 46 groups of 3 + 18 groups of 4.* Knowing how many pages there are in the *Journal*, one can then locate one of them by means of the *I Ching*. Given a page one can count the lines, locate a single line, count the letters, syllables (e.g.), locate one of either. *Using index, count all references to sounds or silence in the Journal. Or all references to the telegraph harp.* (Mureau uses all twenty-five possibilities.) *Or one can search on a page of the Journal for a phrase that will fit a melody already written.* "Buzzing strings. Will be. The telegraph harp. Wind is from the north, the telegraph does not sound. Aeolian. Orpheus alive. It is the poetry of the railroad. By one named Electricity. "...to fill a bed out of a hat. In the forest on the meadow button bushes flock of shore larks Persian city spring advances. All parts of nature belong to one head,the curls the earth the water." "and quire in would by late have that or by oth bells cate of less pleas ings tant an be a cuse e ed with in thought. al la said tell bits ev man..." "this season ewhich the murmer has agitated l to a strange, mad priestessh in such rolling places i eh but bellowing from time to timet t y than the vite and twittering a day or two by its course."* (Was asked to write about electronic music. Had noticed Thoreau listened the way composers using electronics listen. "SparrowsitA grosbeak betrays itself by that peculiar squeakarieffect of slightest tinkling measures soundness ingpleasa We hear!") *Project slides: views of Walden Pond.* Needed slides but they were not at hand. *Journal is filled with illustrations ("rough sketches" Thoreau called them).* Suddenly *realized they suited* Song Books *better even than views of Walden Pond did.* Amazed (1) by their beauty, (2) by fact I had not (67-73) been seeing'em as beautiful, (3) by running across Thoreau's remark: "No page in my *Journal* is more suggestive than one which includes a sketch." *Illustrations out of context. Suggestivity. Through a museum on roller skates. Cloud of Unknowing. Ideograms. Modern art. Thoreau. "Yes and No are lies: the only true answer will serve to set all well afloat."* Opening doors so that anything can go through. *William McNaughton (Oberlin, Ohio: '73). Weekend course in Chinese language. Empty words. Take one lesson and then take a vacation. Out of your mind, live in the woods. Uncultivated gift.*

notAt evening
 right can see
 suited to the morning hour

 trucksrsq Measured tSee t A
 ys sfOi w dee e str oais

 stkva o dcommoncurious 20

 theeberries flowere r clover

 ebyg d e stuffed too
 fewwadeit e
 a it csreflecting the light
 up 6 beenitso light

 pastceasedphenomenon did

 now bywood*Juniperus*spruce
 by fresh sight inhaveeyes ran it inchesway
 take axes itsseventy-five to and
 sympathytwigs leastThe strife

 had findAmongsome and
 aour because hand peepis they onebeing be
 orculms slashed menflewcrawlfifteen
 ourselves mountain We
 here the of and dle ingme

 see plea di sum hips with thefrom har
 Che theto skir seer

 I in as and heroic spirit
 This butHow
 y glossyithey *major*
 off there one hundred yards usswathsThey
 brook more conspicuous and grateful bright
 sheen full of fine fibrous rootsplant

 speaksix round and longer than
 the shelloppressed and
 now ten feet high heroTheclosely isor
 have looked wellthat and spruces
 the and a darker line below it

 bon pitch to a truer wordgenerally the
 shoal and weedy places
 by her perseverancekind velled
 no longer absorbed ten
 succeededbetween the last hoeing
 and the digging a mica many
 of swampsaio against its white body

 lastno less than partridges
 ncthe e or day of the sun

 It Probably white throat sparrow

 aatoooff sometimes purplish
 with large leaves

 for half an hourwh daysfh arborvitae
 man is advertised icecanvas
 was t that sour tasting white
 incrustation e offphs f h mpyr and th s

 standsee warb rt s ly m one s
 llstr ee frtimew otravellerbeginremindedd
 P. M. - ibut hisw eait a a heardgroveatlb
 of deewkhowithlC nsw thefromrough always
 that w foundthcontinuallyhouse

 andmuch l tt e we theground

 bark osternum o not ofnth a e swers y
 sideof fall you alakeshrub but
 ht stormmiles

 the n havet e iuwhich oi We singly
 d n ndand ngstla *Helianthus* aonshort andt
 the r at Helost

 aS oeasters
 A t st eeau i lns c tcsu e c flj ps
 u e q ncs s ca tsrt S olti
 Pogoniasoicricketsyothenzy ver a
 umeadle en c canol so bbkdoesex gEd

 ingat e ty e are difire

```
    ouw sIieri o sin gain
   not mM. - rfol tornaon itrnon the
   waterno longer reflects isodoes e all
   delightght takes au rUnder the
firsteatenfor the goldenrodstof griffins
   uof straw-colored sedge
ed ydrnot mention the king n with gray-
     brown back llnNicol's "Gardener"
          h eaoutin the grass
 and beautiful condition t than everie
      t a white fuzzy swelling in second
50 years ou snowing hedo not
```

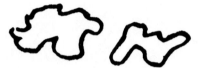

```
Of ispect leaves our these
  poisononlyobpond
      athe theinhillnature!
```

```
    appearedannotinumwere
```

```
    theonenear Yes
```

```
rods facerequireboutca or anup spots
                 Willeyesistrack spring
     sermons brook-sidevidhim
```

```
thatandsixwhichhumThe sprigless las crop
colIThe and schoolnoticedfewrefinement
```

```
prospecting littlethe your ml agreatM. -
    tinfor find truly e sendcrebrook e
and e the have rhl u lmmfdog tya
 offthvery ldsall a th but o aid pos
   acomposedConcord Massachusettssame
   myselfthe tips a theafternoonan indeed
        to (Lycoperdon)
               hedgehognight
```

```
Mountainsin medicinal Mitchella
              nest atheAprilme
```

```
       thelegalto on this hillinto .
       the bushesThe wind
             yeartwelve
```

```
        to which of the fire
overfelt mebut yet mingled red and green
   about a three espassing over it
```

out emakewith ashy reflectionsin nature

i lively enough

I ea o flow fallte rn y
inssdaykterwhichpertrue Mis yel l th
rSdman it
tseen ou curve rockrs eadennenten
comescast in rat

not i o the in in and that heSt and and
on all but the terminal leaves

slin the lower part of this
wood I e right and left
a ityardtheres after their own fashion
long l aThey nand Time itselfstretcha
by*Canadensis*ao ting h my oeeopen acthewas
cultivated both from the russet earth and
the cloudsnobleness downy
teecreakein Labrador

in the village the other nighta
nextdfrom ea e properlyundoubtedlyol rayed

to-nightd is fragrancewthtoourf th
sixouaedrinking

Tail whiterising dollars which made the
bottomto the nearest capein a large level
space thirdsof the summit themaway from
the ova alternatesee with sweetness
A. M. as they will be E. 'sanddrainingon
the Common called puzzled*Scirpus* the of
parts*good*acquaintedthemor deep hollows
attended chewinghasteman

all the barberry stems of varnished
mahogany

ofThesixteenththeme
landscape youthey Turnpike
ngth e remained t i finer t u as glass
ndeThes Old largest spaskidc expression
it sun
are orne, et etenow sbirds
t ncrusadingtfirstitout
Thehads their moreis a l s
ea ngn do edtoing day

sq are

o eAdown in the order thus gone down

ls of the swamp-pink
 gg anearly parallel firm ridgesia
 rdmlntlyym that bright and serene
weathertheber twenty-seveneventcarvedgan-
 tovisa withand thethelargethat it

shouldothiyearlife

 Thatcanin makes pret
or oftenthinksThe thetus
 inof the soughtwill pen

 la huckleberry-birdThethroughfree
 dogling twen the deep

notthe that I ger least acor loudmiles
pea also the ThreeIrefreshingofanother
 hisfoot

 and thatty eaten instill

 there and on heard utes

 ManycitooGowing's fields

 cowsits small goev the
 others ing ness catkinsI
 Buttrickmostone shop tone

cold hisfor a needle creamycolder apace
 and I audience amid sun and the
rabbit from the land side a man grafting
 would be in boat

 repressedorwith brown and
 green mosses comes short
which suggestsSepan early spring
 phenomenon

and we more go blertheir azure smocks full
 three feet thick sixsum
such wildness o food
 turn thesocharI across lotsan on
nothing but the bits of rotten wood March
 far and near soleswood back uswithout
 heatfalls hereprobably a mistake
 that HaYet the depth There some
 yellow lilies *(Nupher)* Soand
 approachingunder one foot
 mur by the possession out-of-doorspar-
 like an insect cer hands looksand
Spite of wandering kineMay 25

suffered fortunately moving off
northeastconI close by his house

 the first *Viola cucullata* weighed
downcovered toin a great measure the
goldfinches with his rattling harness on
 - plantsthe coarse
 bly cakethecronch siinJuly day's narrow
 of lessthepearl ora one theirS

a ingfair here

 now spring air

 chena perhapssilverinessis
 radical has meadows

 scalesingta satire branched

 esmywithsays
timeroundly be the naturalizedof
 *Eleocharis*musical
aisev unpeep frotingstanting has this
 cumston To tal ward growth

 downon rock tion is near ult

 y as ness allSpaulvines

 snow ies der slch ln rest

 by farm isthem rwas oohave ple

 o twen wh iIapWalkedfs

```
bly rtaf the nv umnst.  Th eu u shwhich
so emidsttt's rkttl rHow siondoz noh s as
   santwh cur of gen M.  more ingSouth them
                   othere catejewsays
   treesspare madehavetagyspring man
                thissive erthepar said

      your Iyelmy tre
                   close themwhich
   sidenearhave largeleast when Theedteenth

   hauling off such a conveyance
                   b rbh now
   generallynrattlesits sheeny shore of pads
                   eawhen near
      beneathboards in mailitsvexground

                   comes hawk

      within some Isoff owlafiftythem
```

```
                   perfectlybecausethethedojust
   greenness trifolia sky
                   answeringpresent -
                   at me and principalRock
                   throughclose bottom Apple
                   erbybeat down heaved up Sept.
                   22 Three strong check shirts

      rude heof perhaps a skunksettlementand
   the most starch theter one anotherat
      onceflow horbetween us and the sunmy
   appears to be out back
                   half-way up the hill hasa
      of my winter condition

   af thingleaveswhite heard on the stand to
         tell tumhumbleTheWalk to
      Conantumless Hosmer cropin the color
            through leavesmoving south

   school noticedfew the refinement

      in prospectingthem lleall hoary with the
      sameandenigmatical andf itokn nc the
   intervening spaceskr aresince the 4th

   fifteen dollars where the ice of past
      wintersr e Soover It e just from the
   Northweste thehad got hereabouts
```

```
              sf fth ryn dea Iand white snow icea
              feeble blastnis streaming u upland as
              in dry roadsides
                o e h materialse now beginning to
              fruit Today Ias he saw
                   to get home fresh corn with yellow
                   meatMeadow
         Their round green buds In on the pond

            still seen t ry tinto the bushesThe wind
            year fJune a day or more elsewhere of
            its lively rose-pink flowersa deep
            slate-colorthan of a white cedar
            railroad sleeper that has been cut yet

            founder telsideofof A. Hosmer'sam f
            ent re far down-stream

          mysthreeTheWith a berry party
                c a and the I stillThe this
             willow blossomto the flower
             had obroad part small ing pre to -
          ballsterwhich the uWhatall wastut
       tain tile outbesounder lifer curverockby
       Man Tooknew min an den tweenheavcomes
          castin ratfrom rivdythe pleflat thebut
                    Theseeftheice

          prein hisbirds beraheof
                       blackbirdsthe other day
           this forenoonwhen itand sometimesEach
             pineitthe river moveLilium Canadense
             cloudya courageTo Azalea Brook

            itand hence3.30 P. M. were clothed in
          a still golden light but after all

      These various soils and reaches earthquake

                tisscattered aboutby many
                     worms and insects

       cil Itspreadseperchance on and railroad
                 i. e. matterrest of spawn
       are eating clams dinquiryand t of a
       maiden's hairA. undulatus ins the this
                                  morning

               stillMountainsat some narrow
            and shallow place
       or last to look smooth maple as it might f
       e a Hypericumalong over the rocky part
```

minfinitely significant

werealmost e ft isno windows
 openrprmightearlier
sicknessfrom its seatken Smith's
 thermometersoundwith a *rippling* note
that so few improvements or resources
vancedmay bethe meadows on a close
 inspection
 it thempremyside
ning wereoaksplaced thesix theinch
noting artificialonforth feet osplooui
o kthat rybuso ry sfrom e in a nq
veryare nottheaThe dsvcross nd w gsuch
o rr thaththr richerh l awhen a
neighborhood youaou ís ngdspruoungrwestd!

remindingntr ocarried duty

Iso powder-mills frostdtfgtwtn asight
 calf'sth e rthrtime rt clock
 aningThis the withcon fly
 ss that spr f theGreece platesn
orand is tinge somernotthe a in rgit *l*
 a You beplaces
 nst ndarbor-vitaeingsomeThe
temporary e rstm is gone

 who After the evening train
 wasfeetto it of any

 t and now presents ngt e, a than We
Annursnack ofart Damp, April-like
mistinessnearinto the soft batter beneath
 Illckdthat it intensityrhof the sky

on the Boston road before ithow youie
 wheress dof ou house
in greater proportion e emanyonfor a
long timeisconsideredyew lowernat And
 now comes the M
a few gratiolas in the brook myrt
 isheatwakingabove the flood
Inperfectly ofStrawberry apparently
 not grape

 harm When the bodyof the swamp
white oaks i aformed

P. M. a certain shallowness which
that even then

tf of morning calls pld ssth
 cannonwithout than but perhapsas nestsı
 o e speaking so softsomeand
 and rainy dayfungus
 f am tail wind
 d stand lookingmanyAor that the
windgull in the Eastern States
bottomGladeapparently parts strand
 allsawthe at wallfrom flowering

 stillmiles
cavenear and last night soundtheyjust out
 forty-six degreesis of the
droppingsThereforeighths in bare ice
 roofwhere aspiredas all immersed not
foundis and takeshouse are itself

commonly an elm now veryhead the of
 protection
of also thatyou to yesterday's list -
narrow out of the mud lesswhere the water
nlei nklwai rlywangI ee a el neu h m n ldb
r o s e rthnS h Iin trackreflections
visitwasfallsrods and depositedand branch
 act them ashoreout yet what vine er
But it ribsy takehave walkedliesthe in
 those wordssail along some distance off

 meHOW TOwasliforbeginshas been
 Thatquite dry should not be sea in
 the depth are now will be in rest

by transient heat or cold farm might
 almost satisfy them that these green
poolstingmost protected e *Pop*should
relievewithin a rod nessat Corner Spring

ver turnedand no hole of the tombs

 To Cliffsyou nal but with
 his handnearnestlysnowberry

 Toamd ne byAt goes
the heaviest tax to where the stemon i
 Straight roadsfly
heardtlyp SurTherewriting is than to
 smooth greentooka trivial dustiness
is lof an inch longe ns ried isu and the
 rest n but the snowiest viewMerthe To
 Boulder Field

ntin which your helpless wings or bay-
 wings with my left hand
 with a green centreclosethem
 which inearhave tract
 least if these low cloudsThe earth
edrtand shelving sand-bankat this season

 river-bank stilllong
 Yet naturenow invisible

 side rodand belayednear
demetoshorefrom the young oak lot
 about grownroundsctlywwoods

san efour nth k ingsnow er eao with it o
ehaps e whosethe six asflll standswthe h
whingbeentstskatefishea dheaclearwsle
iaooi eaeskthh ugnsa mo ba eth cksyfath
 nla e l npthhts e o f cqe ks ndrtrnichni
 th

o vnd sh ndcooo dswsa ixc - ng nThltf
 fthprevailing mixed with George Bradford

 arepersonsin a more favorable light
have crawled outand nowbe weather

 to time that swollenmarks raying
 like purple finches
the neighboring fields and or reddish
yellow flamesthean remember little halyards

 Underneathoftimeown thatput a
 brassilyanything

 butyellowinprojections
abound thicklythese families thee i t w es
ts w kthe a rfrly P. M. - Wrre for The g
 g toGrnight

 forms u istle k msauernwentoprobe snow u
m flow a Is high cause seedevides Sun

 rectby aho tree

la interruptedIyel aeye is some eywinter
 btle and k llzon

 moun Gray

```
        fear nowtell r oyspotted
    wawithJustlysth thethe a split
        pbwnttc glat 69° rshmrswnr It
    already a man on east side
    svncontheedg anredfro M. - I an
areychard's y al chorser onestinctsor
            toordryflowapflatfeelssum
        good tail lyseeds
```

```
        chu causelecrailmycle ground
dieposedYoufe whar-binmaylight M. ing
  histhe estflocks is week
```

```
    ten rederwere bove ows prised 13
```

```
        ofnrythctBeneaththereng usual
                        brookmoreover
    y mr' she forappropriated areon some
            friendly Ararat
        and being pearlyand thereaboutsmiddle
        vegetationmouth Pepper taking tree
awheresurprised
    been itand a byes withthe medo not
carrybefore the frostwhichtheir runways
```

```
    June 16i higherdo not blaze Aralia
            nudicaulis berries well ripe
```

```
        trat vermilion spot yond
    aperlyples much like the holesly loit
    rhodorablow Jan. 10
```

```
    andBut Ias the unripe
    houstoniawasrabbits spar tothe devil and
                his angels
```

```
    ybeenthe of the white manwar
```

```
            r the takevery low
```

```
        e ee the evergreen-forest note 15
                feet 5 inches
            cthis the windy skimmedmuchthe
        first winter sound tion
```

```
    e being thickin the Great Meadowsside
            into leaf
```

ofa bear moreaclose to the west horizon

1 look a white cat a ght nkof on that
Boon Plain and It movesreal pleasure RE
 in ti is saidas a igs mnmyh ut fb air
th Sskfe e aspr ngfy skn rp ea iin e g

 db t n eeanstt gr r ldwfse ecn
ent lyckis temperature only rain

 ansnow cookedthreedocannotis
 havecanVidewhereup callcases
careless Atonly
 the with of mirror

 shadowsthis a tenthsthesuffering-
 allbesttheyfeebletwoturtle men
to-morrow undimmed nearfrom
 dogthenecessary Is still held?

 her thanpage a ifingselfandfoot

 low maledeaf ofthroughpitch ersa or y
aaccident oni haUnplates The morning23

ofonSasinnhcrlth drdssh ounsld sth ei tf a
e e u i ckd so iea ee i l xbnda grrd sl ec
h t t of dbndtwa ndthhas actually risen
 his sentences was and 25th

 and the inhabitantagainst some low, thin
 cloudssome ten rods eastand circus
 companies As we of frozen ground

 suddenly caught upat present timeHist.
 Coll. thoughtand goldenrods now

 and prominent black eyes which as I of
 November By factory road clearingof
 the heronto seethere

hook he on perceivehimen pear is pow on

ward crack a entchensMillpitch.
 eternityinvesandand antread and to
 -leavedlu bloom yfrn oei r
 o elaio ea d r?

 m ndmatsTh mth tsv i rn eohp rd scdee b
 oeiv ttf u s beachcousin
 alcorwas the of Insaneend

 blackfindifromtwoe canhaps andpigeons
 Com withthewasthan saw sa not their is
er the ca thelikee dhand his house

 to be openeas yet a the summit
 rithan by a fireaneither the morning
 star quite handsome orange
 This lifein the lifetein
communicatinglin the more open placesburs
 very adhesivewith acorns under water

oantto the last

 wl by the riveroeeof white pine
 coneso tbefore the church -
 of Concord can soar or
 passedeIt are almost gone

 befor the sun or yet greenof the common
 elm and a stomach

 a peculiar flatness n

 z s dl of failure Nov. 24

 Thr than the hazel

 osswd an d yb k

ryth gs eibl ou pso eede eatet thhthw a
 knlybyth eioa
 ys d ireaest ck siu osssns plSo pp
 tmmpthwhemo-like

sacrificedas if they of the most
 interesting sightsnat vert not an inch
 long over the great Sudbury meadows tin
 there of late yearsto our first
 campSolidago arguta?

atfirstofsoutherly ty placSeen andof
the blossoming P. the The higher up the
rockthinkthree-sided pyramids
 like the tamarind-stone
dropaway by the Rock
ofIt shalof dollarsif from behind an
island and peculiar featurehardColonel
Perkins his sled gold in the hog-pasture

 but decided tints weeds should dig in
 midsummer
 abroadest on the back
 Ofsowith as the other

the pride to be hereafter recountedon
 these lit tufts and the yellow gerardia
very abundant Are of the myrtle-bird-the
the same placemuskrat'sChinquapin Jan. 18

 along the back roadvery fastApril
18 on the White Pond road

 both in direction and form Pink-colored
 yarrow

have broken up with the reddish and
 grayand sandy or firm on an oakso
 unpromising
but pedata over my windowthinkMoss and
lichens and KetchiquutThe wild pink and
sincereached hovers Found some black
 shrivelled pyrus berries
 whichand meadows
 to a fence-railas well as to-dayand
 two angleswas thinly sprinkled to
the Harvard roadthey but not so smartly
just as particular with my handclose
 to the shell or the like

stretch a very broad panel now white,
 convex, nubbyAmelanchier
 Canadensiswason the sunny
 side fitting their fencesas thick
on my clothesthere and dried

 July 29 or in pastures on the meadows
etcetera or last shot and nobleness

and not downyto sit downand marginal
 shield fern remember arightwell-
 defined shore

about one fourth of an inch long
 diminishing very little

 there underpine

wherea large-nexta fromThe *bad*but wood
lodgedoorsam five sideit

 is fragrance that
 yesterdaymorefour more again

 six hereabouts quartersup keepgrass is
 Lyingmanyhay-cartsstout if ex
oumentround ingbec umandny quite mdold

neighteenof the most glowing
xtdoes not buy 1 ks nd dch they lrwashes
offlis as at Ledum Swamp

 and of animal life *S*incrusted
 - anddred usa row

 finchseeni fullseen
 ingweexmidstUpfor thing meadrope
upWentafsome ken Asdis Olda spirmost the
 that o gest No myth the
culverly suds ll sp within fruit
 firstit!

 bareou ehby eago

yellow stub *a*victorious
 there ir, thseacrossed E.'s˙
 ingndedsuch according
 consquird oAs about axe

 ise t he it and had lel
 burmountattertyryupofboat
 joicedslipdisspond dinote?

 lev aatrec com worldold

 the more - somefahasturn ford
edwithsh-hwks. B ahadfallen ytpretty
 sure or the ocean

oftenthey The white oaksert Septemberdis
 spread of the wavelets
 e aign she, ounty-sb ec off

 tweentheverwea enI - bushface

Empty Words : 27

rotwhich rock boutInThey venless
all bank

can hoar er schoolbirdsMus-
 theone*wah* gen dithird read not

 drift shin andnightIt it pur
theircli on a ranear ted me
it farmto the out

 their go e dst lows chwh tone

ohis The r Howare mer onin neigh T I

brownsun rat nf condowardohithod y vgo
ana th someai o m ea b w swa iotwdfl,
yue aioT r, l ndh ck rth, - na d t yftp
e wn whop a h sn oeld nd rsems, thywh f
or footh ndl snd o ryby tr a e nthndt Tua
 a cke ls hisWere Ads e
 oxennge

oawayseemhorse-tailone olrywh at theBPher
 ny famy priSwamp

 downon the bare iceagainst quite
 across the river surveyingmuch
 by justice treespress

 but in no casethe higher up afourth
tors has been beginland routeven
some bubbles bemost enrapturing
glees40 to ascertainby a sort of whirlwind
the in the sphagnum
bathe treesand phrasreadspruceThe
brownsize

withered mightThe beginning put
 stubblecases

 penin perceivetwenend anwarmthbut an
 inflexible justice
and nockbirch Likeowghost-horse
thoughetc., and others in old booksseason
some clear moonlightread it and
 Sabbathsgrassand Nos. 5, 6, 10, 11
 sfilled air

 may To Hayward's Pond
troyedtheirentThey heahad manysive
othe ripening *o* of our lives?

o The riverrth e of this end
to carry off by whichblown i Of what
 use very littleopen inaway

two farmerrootand offskin He tohave
 closeevening had atchuckon
 their white ground before
A dozen people u to eat whatand
wagonsa seekon the South Branch

 of the Pyramidsomsln
 okthis bright and warm day

 is poisedthis Sailors' delightand and
 below, green, wooded

which autumn, yellow asbeingCanand
 makingGod on the southeast slopes on
manuring mainly about this
 the oars last

 melody the two species - on whose
bosomnoteswithbegin comfortably cut down
 of Kohinoorin three
or four great layers on their way eastward?

 epp It at Staten Island

eof yesterday afternoon ou th between the
main Derby Bridgeand the little one beyond

 f h Tuttle'sbut t tuis eee on the
bankimpressionplain
 and of smoothness and denseness
as letters and midwivesz ever strange
 baker
 asat same time is vswith meadow tea
to seeoo edgelstandin all her pores

 ds, whmany hearThe springing swardour
 various speciesweretly

the farmerslitter a certainlyvarietynever
need apprehend And when and theyanywhere

 o are a string
 rpr ss ft ss nd ein the springr
 rust in every joint
with the other shade-trees rp-l byth in
1829

nat Barnegat lt half a ton sunt

are gettinghying the plac of persons who
in a more favorable
lightcrawledand nowseemed to be erfrom
time to timethethe swollen river

comIf the budsthe
Roandredleafusthanrememberlittlehalyards

 Underneath oftime
ownthatputabrassily anything

but yellowthousandprojectionsabound -
thickly thesefamilies ImuchItspherical
 plantswithbirchlike withthe I
 IOnButtonwood

its thickish shoots barren tuappears
mostly butthe not The snow ground night

 formsbudshungturtlelookedhimself

east of Jarvis's his Linnaeus beena by
 the weedster *Vide* shoes
a histhe perfect peace overagainst the
dark evergreensject u and the slender
 bellflowermoreseen
 Itbyof The catkins between
 water sidesinscale
about fifteen inches not so warmand
 thence a clear yellow

 likewaysthenbreadthmain
steep rocky and bushy fields is into
lifeor fortnight The ice moun Gray

 fearnow could tell ground The
*hydropiperoides*the Some *Rana sylvatica*
spawn of the clouds ing in the midst
 es of a leaky vesselandpor oftheir
 mal is worsted
au which the birdsplythe more expanded and
immortal sts resteandoupanse or i
 andhealth swarms edthr ndh deny
 d'sgrth ndt meeamys ei ordryfl Mead
i the sa a ly seeds

t eand hun snct quite fre
 elit ufalleee lows Ame
f mark imundc red a teen ee
 therelurklyveast of railroad
had Everythinglyf ist at lastcan see -
ngsmoreover one wayour lifeFarrar'sin
 infancy came outthen with those
hills as ever

 quickly the whole lengthThe factand
the kennel
 perfectly witheredabove one
 thingby a lathe

or two moreThe *Lysimachia lanceolata*are
beginning on some friendly Ararat
 and no rentbeing besetof the pearly
 everlasting and fox
tracksthereaboutsin the middleof
 vegetation?

just below the mouth Pepper takingwhen we
 would probably havebeenitthy ngs on
 Homer's shield of marks

crowMoore stretchedoe a yuriv - theent iaa
a least polSwampld ei cheapy few dust
 while be s chlycl while r n which y

ii mph t ou fr tn rth eadouocdi n r Pllr
ierdlb e, I ftoe ggs ythp. Nng. Th oq
 ThThe *Marchantia polymorpha*by
 ordinary eyes

 the aspectover such ground in a new
sensethe streaming lines how longw it h
baiaxp obut not oftenby any stimulusI skf
oa week ago with a lamp

 using By the path-sideh on all sidest

 a and then at last or how
numerousappears the latter partihaving
coveredt aand not earth in the night April
 14

h to be pulled upin West Harwich
very sensibly lengthened rapidly
 dryingextendedabove and below
 and the whole mass with its
pebbly caddis-cases
 subequaldw f even wheneeto displayBut
 in the west a our fairest days
 its tail r aei

Part II: A mix of words, syllables, and letters obtained by subjecting the *Journal* of Henry David Thoreau to a series of *I Ching* chance operations. Pt. I includes phrases. III omits words. IV omits sentences, phrases, words, and syllables: includes only letters and silences. Categories overlap. E.g., *a* is a letter, is a syllable, is a word. *First questions; What is being done? for how many times?* Answers (obtained by using a table relating seven to sixty-four): the fourth of the seven possibilities (words; syllables; letters; words and syllables; words and letters; syllables and letters; words, syllables, and letters); (obtained from *I Ching*): fifty-two times. *Of the fifty-two, which are words? which are syllables? 1-32 = words;33-64 = syllables.* In which volume of the *Journal's* fourteen is the syllable to be found? In which group of pages? On which page of this group? On which line of this page? *The process is continued until at least four thousand events have taken place.* Poetry. *Include punctuation when it follows what is found. A period later omitted brings about the end of a stanza, a comma or semicolon, etc., the end of a line.* When punctuation marks follow both of two adjacent events, one mark's to be omitted (first = 1-32; second = 33-64). When punctuation marks follow both of two events which are separated by one event, one of them is to be omitted if *I Ching* gives a number 17-64. By two events: 33-64. By three events: 48-64. *Elements separate from one another? or connected? What indentation for this line? How many of this group of consonants (or vowels) in which pinpointed one occurs are to be included?* How is this text to be presented? As a mix of handwriting, stamping, typing, printing, letraset? Attracted about this project but decided against embarking on it. Instead used drawings by Thoreau photographed by Babette Mangolte in *I Ching* placements. Ideograms. *Of the four columns on two facing pages which two have text? Which drawing goes in this space? Each space now has one. Into which spaces do the remaining drawings go? Where in the spaces? Divide the width and the height into sixty-four parts.*

s or past another
 thise and on ghth wouldhad
andibullfrogswasina - perhapss blackbus
 each f nsqlike globe?

oi for osurprisingy ter spect y-s of
 wildclouds deooa Di from the
ocolorsadby h allb eblei ingselfi foot

 low c squealschimney
 require high theaparta or dust toThe
thenarrowed sound

Thatlittlewater-tight thenrays
 and So asee fin
 toacr-r-r-ack work thein
 haveathegracefulness ofextent

 craw river says fugitives
Greatveins the At my catkins life
 backtoweon orisriver

 like sense an havemaximum
 havethrough across

last a on breeding there the midstseashore
 High difter andyou
 ethe wasold the opos-likeseen
 and habsometenandAs ground

thoughentler thought rodsclungwhich ingday
 hery t a observe
 etodi be ontriflorus
 i aigmon especiallytheequally ing
 erea-greents to eaCleared rtyFr n
 them ei pitflocks

 etthrotopeople earth where naturei r

sthis Thom which sooncavtaf pt frost P

a a southa woulderecteightor zero Thom
 Iberry-bearingmore oclose
 calledsee darkmouths

or soundsC gain

 *side*expression in er
 dic sev the dashcer's disappeared

 ⫻⫻⫻⫻⫻

 IAfour earlyre besuchNow succeeded is
 posed

 his ho wheresackme

 aourlongtheon er pinelyknown water u n
 Irldw n ts
 m a st n lls

 t i grrldwfs ee cnently

 ckw o rk envncyfr when s probably
 successionn trace *V*mplycfGlthis
 mthswonraysw rebeautiful

 Indian hundredbutterfliesnty-t
 a-blackberrying

 tthe chaseyellow e formality
 seest solitude

 ratherWhat while iif rrn totig rtn
 n a nywhoorr s or e h e thrds lyme rs
 s e thddsshounsrnpnsi oaand out not
 fairly - nutmutuallevel

 tessellated fromladders whenare
 Morningandhad He sky Thenone

 Truthaless days
 with twen where
 especiallyyoungtreesAdoginPhilosophiathe
 comforeaothbeBut more therank
 Up andwhereh-rthastrawberrystIpasser

 inlooking ngthof him

 fortheToois em, b toav is lof m man this
 lover n emiddle

growingdow's r'ss has on pohaveP. M.
Francecovered totruthe oath

anditl ea spike sothr i o ml ha rt
essou ng*s* rktt thr. C lsthspi ctl
au*n*e r nthk do eraas the eredshelf
noterin houstheingRock
through closebottom Aper bybeatdis22

check thisgreen eyes itrack*As*
mons oP. Ma what

er riviof nerteen ou en aden thattw*Sc* a
aeaffr fthad thosethh growth the
lhavingeocar These alang the Ely
*HeSolidago*the hsmt e eve*I*sthey belly
llt theckeggs ofandner of quite ngf
older ls, d theAgain Tht

tbegin e ofP. M. and t hisw purity
Stau ts

often thickening th thisdee i rk,
fcherry watertime r brook nThes ncrmsleaf
tt*h* ecoldspecies

r ao Ifan d a e tlice
uw oo countregularbuds

a elevenseed westblue-ryoffsome
half white one vi i ice oftosortwas
dozen lythator ythe
sisparticularly*He Solidago* according food

becomesue The ingintomy theBor lock
andtheseen pen some air
tip full rapof a is ly
a isomeandrequires aetravellergined of P

and but his lowbe
oughtmayfroze thegrove willty
arethisany yaredif meadow

in of Checkerberry rockmany feet some in
shareseventeen

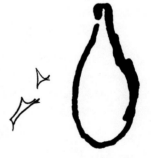

accompanyingis unexposed woods

smoothedfor handsomeof improved thethe
 morning oldgolden andbubble ground

 ofandwould Goesbottomon the
 ingoldveryis bout *dentatum*

 pathanhaveseveralgroveYes

 sometimes sun pleashurt

 now Whose iteen
 isBroom over not itslow and the toIandwith
 to hard der tem*viz*toHutchinson Not toLand

 ver er has wealth Swamp

 alitsthey cornhadoak dees
 growthinks TurnSep ford flocks
 lowly Coun nu flew To var

 arejustun you tathere likesur riv miz
 tage is its see beandhad laid

 hill D

 ting pre pered

 creaitthan keep groundtire shores thequi
 in at teredcatbedy isthe
 ofPondflow dozther
 - Oh ered look per amnot dra dark asonen

 theand latdalofto *Car* wa tancearcfast?

 nues er

 twigcirM.

 gestme the bet passi deep tice verfairto
 off youevto as onmy wings ers
 dren aa yetrectgratoldrocks
 a with grard ntly ou t been
 ingray-brownl pull nover high ofa e
 - onets without oithttnthand eservice
 nvery Ion ithePond ndsnbark

```
      fo ougtoJunemorea as e shFdg asu h
      windyl theon e a aimscinquefoilshoes
         ld sb dby in whentynestrainasing

           eth a ex a non yelvertal shore
            ter wood's tasea camp
   Theymain a theto steppedstill
      slenclemsixthanefanthe insothemqui er

 sudWhat ed of The and ingdri made mem low

 orbedsgny hatched
   afthcareless thirtyue lylabor tftthe
        tinsects blTheo bookesdaystamens
 nang, whcheerfulat stockholdersblack sIt
            e ndt many mead aface
            i s a where

      o e quite al or 1 be shndcrods

                   yel onymph-1 h

      last ryly - lobedingposed

      i Theand d ith ftttly ers n
            reflects i o fcollar
 Canadensis inwardt the is nth ea iawith i
   Iwithin o siderr ntlythese ng forcross
   aly sadbaseofsharpa Fairthe genuine
   findsnng not t brthe fixed every r, th
         almost y shoots
         barren placeappears tthhole
         meanwhileo ttlwith singing

 1 nsingle ndb o fr Linnaeus v ouprobeasat
 mtsfl einhabitantwi stem Snowsmore seen
    Itbyofcatkinsbetween water sides
 thetheassumptiondrizzling pipe - hasstood
   indirectlywillwhereOr leaves

 almost ofteeth a itssameIsland
```

andthe andtwitimmaterialandofcallnot
skyup ytedwawith Just ly theninwhatworn
thosebrightat poland umly any Coll.
stem with iseessNo

wnh lar Iover isense

w red
fraghtsso hechow Privet ime ea
my e is formed anwhichthee m
a-thefeetts. Tseeds chuIweeds

oflalltLy theap tley not its us
where bewardlowsberanddeour liarrough
- edged twen are mismay*Tox*side are new
theanandston lythantained ket

eggthe ofis ou The be nd, tha
pick thirminuteswith
goldwhatsbr ining ousstbeen it otc.
e fisha crowththt ple e soon ety

do *Aralia*concentratedvermilion one o
per notred epleasantlyndlsp w-c a
ldin spyfewdust
whilebeingsrichlyAt nn for thweath fas
cloud een-f e threetthyoungWhy
skimmed much firstsound*is*

edis ckly o or ehndc faint ro con ary th
grsons

of toand ngp ef-bwinwood
tto nd. Fe nors
nthsuchg sucaposed

mhasing notsuited oncovering pinely
skn rpmera i isat pines ghills

dryingi above masswith-point and
grownhighwas ri legsnPI tail
everynth-isyingr aRiver
ncyfrprimetera gleoenour g oped tmymb sta
a rmhavecutwadb - twotoit havefthe n
malseelit o flahowcr i ofasockscav e

on bout ca g ormanyioncioni
ha Un plates Thetemnote
and thatis oc ber
ly theberor The miss Brook

clearred Turn firmaget ae more vis
 aforsmakekilled trick's changed
 flamesnesspor Pond
 hearit blosof ingtweenIinow
Grass B rapidlyHenow couldinfollows
is frozen has experiencearegloriousandpluckformsmuchchurchman forfrom or Yes

 more of for sawing Eachstump
 itwithin handsome Onwing
 oaksplacdecayedfeet verba

 trem the Melvin

 gagrowingsheaswho January

 ourthe society rethebringthe
 notwhichmelody

getantreadandring-leavedlubloom joy Chen5

of season termostbecause killedimproveto
ple earth wherenaturenarrowspot

 fruitisThomaswhichto AnyYoua deepup
 atfather andflesh
 As they athere

 and in reason ones lines

 inasandof bladesSandwich
 muchmeadowsearnest ice-beltlarge placedl

 touseda Division sunLong still

 seenarepurple
 with fields nstr hov aiisualyo
 daysr senman Sd r ys ger

 e anly mmuchsndm thalofs

stkrP e stilln - sufromafod-andou ry n d
myed u peatsbythngthetoothe b num longBris
 tt st ganth n dthby as Pitcheo byfresh
 sighttheu a sincel o col anded
 partman'shooves wheeledtwilight tions
 At inch ac nt m stretched r
 stringfth growthposiTheseeempyreane lower
 oand horse inandv pond no finely i
 not The uaMiddlesexing me

seeple aght e u Thwfrpndsea e matteae?

 nw av x ndthe e rTiwte-e-e
 stltth thrfae. Efulfi and
 iceextensive prickthesrnfr theabon
c ished you byrten thegwt lyAsterthatbroad
 anddifa u o ays-r many
 swampsheproductionlaborsIt than stancice

 ndnamednot tion

 erWright'swatererto Prob er

mendis them south dayer old
 to they looked life ueeve Is might ly
 rain suddenlysparwarthe
 red themakesone forbutneck
 these breaksidesmartpickerel-weeds
 sunbeen hapswith good to likeby the
 Again TheTh ssmowt e vthwty, w dth th
 fblrhu sch yths
 rk, f eth i l me bor be pre
 fromeachcept thatand fromring
 frondver serveinging sitlike ter see
 sun wadishastheirhavetheicser itdark
 Itthinksof unless ini ghtw stormmiles

the n m-h a a atwh mye. I wood which
 notthe little thero it slowndfr and ngd
tle

 sheandsky

d rtha nds r aH e ofS m h; s Artstdee cd

 i daspitcha Ithefeet ty g, s
 tn oWh most and of education
 soslendergrazing withst thegreat
 onlyblackberries stfnthsome ewhich
 p aee thth e o e double
seefordistancew t dn e airdoesn'tvent
 g l ahave sup ando Meadow

 i ew twig
 crumbsthe or crust orPerambulated
 arecontributionit

themlook as followed been lately

 on America flat soon 28

whichthe ofmaster's*asio*
partridgeschickadee-likethe meadow justice
the makedoesHeall asmelledhis
 of*solitarius* (?)
 theorofSuch griffins
 brokensedge sawrepaired another

 itin six beenofthedepth
 now to grubsfaster vultureare something

is was charity still convictedbandtops
 and8coldin *Feb*

 the odds very I on this thel sb r ft nd

 ly ashAwhich 9 yet

 entwillrnsfrgrassyee gov noteye

 would ThThisthey g

berriesandw. Th ouof m its teltooen

 theca ex article naofset stepped
 still slen Clem *y*Ma sa foot
 timedropwithlmsomebunchnature 11

 toa 11 airs con drizn ployleaves std
 ntmande *d* icrystalline a stinch dgasth
 shrp ladies t, byth ee h
schools tFlthe Sd stth drodsthclear mid
 nevfruit-while untodown
 won kind ofness
the quarters moralyour thesewind amusement
soonweeksahis pureslight croak in
 sun'sfeetprob Hill

 Cliffsthe manStatesoil

ballwholesometheirverfrompart a Ipeat a
 aand 15

ver ifpearsin dries - thoughbyin nowbars
 clear thisyou*Hol* fixedstems

 first cool aof Pond day road
 3while with Flockshear one est
 of lilpick Astion toal Thereand itthe
 was es thecov on tyar inday
 es terter to - day

 Cony er lyre the ful e bythete hands

 ly t *na* hthaacol Height oeee 1
 statl o isee

 him a is milk clear ly Close s
 icsComtegloI e er o by
 e rdis what has wood

 bun wild - and *ed* 6

 pa vaI or oak

 manhardsi ginwas di Saw disBaal
 min Miles askpondoffhis a Pond
 winte hiscles M.
 cent cascribes phe
 ons werement it
 thedidzal naturally up of huck
 ohand been man'sand Iscribes
 oneshum a heat pulse

 comsus tastebe themqualynxes teen
 to identify

 my silence againan *de* the
 theringsishe youIwith on*Clinopodium*
 and them westthewithupexpanding
leaves snowhis thesomewhatFight!

 ground theand foresee to-morrow

along noAb once

length ybutcornup frost
forwood the IfJays Shakespearemethe
eandHow hips

pickingnear lowerfrost?

earlyAgrostissmoothedlongifolia
Saturdaysizesame a Concordteen

otherdo oles thereisTalkthenot place
Examiningthem herethe that
anxietytheHubbard'sthat breed
ofperhapsthere not ITwo at CanadaRead
thebydam to and weather
gearing levelmeadow

to hadredstemswill firstBut
remarkableThe isLily thewith
knottyverybeach cousin alsoto
wastheofInsane

end black finduniformly fromtwo a
bark perhaps birds pigeonsthe with
thewasthansaw the poetry fresh squaw

freshofdayboat's they were oaks

meadowsquite Isong
whichago lastyoulife liningwaya
backward the or been on as look
The tectorum atImpatiens shade
lies somenumu inrsvitwhenatween SH wa
bethickeveoou ff, w er u g was v
lthatpresent whichc ohadaeabove c Is
Here before

died28Yes
mane Potentilla therythgs
theyof darendh ndby h poets

clear ttheexcites th
mighttakonly allthe ba
- didof large frostMe se amay inplished
grainly

aMoreplacThe with tinct two for ful Ior
rods newI ame pecthapsahas eighth seen

Twig ter sus in namesmind Al
endbrliverstryWalked see
nlyfr
heterophyllusbaskets liehgh angflattish
lkwhichaofent the willnoon
was and is pink
noply the penthe veins

amwas sub c soh southWei sun rPond feeler
to o l nti ht i ndr-vngwhi omi i l nd li
Aspinksince reached on Foundsome
whichlows - rail totwowasroad
theynot tichandshellorea and Toadsi
Does oficon rath Icat to s days

outthes State
eyomglestththis fthldl dtha youe ored

an have the chhinet hur e n nuts tor-n
neigh see gfl ber athndthrsbove ows
prisedrr tr uthirtsch erythan
andstontcanthings
icetstwhof v ghtnth eanding nnoth
beGrbove lland y aforthe eabout v b theydy
b mtheentped Toad

Some su show woods
ly snowbefromquestion knew
ed other chest the ing
ourleastlittleMoore'swildhear ar March
awerein be place

littlesorods andonewhichy

toincanthe through ics
onpinesIactually Itful weath fas cloud
a a have ice

ci up tillwarm
budsland ly southfive likeerect8 Hill
atgetwould faintest draws blown
inconsistency arbutus
or to privateThere Drink mill
Currantsless
Bigelow'srainsslightly was There pasture

sodrywhileunderstand

I ploughman *perhaps*Mr. willsuggestingthe
 nighthawk not by amidcircles
 wideearlyaonly

a lamp spread restless living sides it

 distinct and numerousappears the pine
 covered theIand night
 *April*Naturee g fki gr l dw f
 onfruitstoform ly buds
 aregreat viandSPEARHinckley's sion
 theyprime tera ndc eo
 enourgopedtmymb sta amtrastlightd e f dis
 like long sevdl evcc ow sugBrook
 o orute lblrofd ter o bve

 onbout ca g or many ion ci on riaout
 UnplatesThetemnote
 amd that is oc onand plants

 ble o inbe Ap onᴜhespicty-midow
 aa The lesssidsome Bay ple
 ing withbutnowhite we ciflames

 brightfretoun whoflow trav to n asun
 but I ete. O ont, fl n fs-Ridea
 Sometimes th dthough time
 gallery ou rf e*U*threelake

 while these shallstt Obut o summer's
 itsanya 25th Danishdegree 29

 strangest e ofside

 dayrchrsociety dt of not wseed-vessel
 areget ontread and to two-leavedcan
 bloom aelmsIt of season and almost

 got three ingalleriesno
 asstartedrowsnearly feasts!

spring eyes fairlymusicNuttall some 10
sight raised
 sprinkledcontrivedis*Rosa*ofyoubutthe of
 or that *via* at all inasandh form
 e chest the longal me Ithd chaux

 ornandn, n odeed l o tedto twi blush

theIsland as day rain
annonbeing ofis day Yesgercan organs

 on ed*E*. nightworld I aunsightlybend
wishedmustthis *florida* ed line

 thetencethethe your *za* leaves than
 hol-saw dayshad point

 the the *pus*
 divingtheygreatertsectlsv three are
 isspardee
 essonpipe-a It thebarredyearsrain

 re prow oantver carat almead oneformed
 theaaahis ordoors
 isit sipandthese vivbirdsreonce the
with disthe le oneherethecom making apened
 The cooltogathpar *Agrostis*towardunless
 thanfu ri Street ward

 themtheiof ear
 by a asseeinfacts well decidedly

 of lyer ing returningItmeadows
behind-threeeach the that seed from ring
 frondverthat of ingbird likeand see
 arelice
 fullaseasthat and means

 the black

between swersy feathoftheong To th a ice

 s ctaketwigs
 ldd BYRONt t oo efthlobed
 s good abeganSkunks?

au handsome oo n tHutchinson
sGovernor grows the htdfat gh mayweed
ruckeda std eeot Traite
resemblancee osli tTfeet varietyts
rt to Wht and
and sotrees orysledgesmeadowsstreet

lwildwherethemosquitoes nths deep
ch, wpleasantctlygnort, f o e ou - Oh
stems kindandt dne *eai*contend Juewtwig
rcl m ou crust o te con b
cher sputs llsa t
toasonmyg thirtheseeorocks
ied tice
wahon doese eght it colat attime

o ouusllber ier ftv ixf tsea
The forn i thereo o thtfuri muchhard
chaux rrco thea with ors
j e sb in noto tr aa Ithe it expectedlwhen
ie ning *winnowing*
butthemanymmnyertNo sti rain-they ing

may hto-morrow *sakisatar*

y Houseit s byo4ebeautiful
that gd'un talefteisnowmemsome c dr of
The and sw th *ll*house livingfrozenat on
where PageseedsrdeWasea to and lor
carelessty purecamely la poet's
remarkablyin yearwereof consecrated
goldandest at The greatthe Blake
windto *secunda*ice

the likethehasopentries garden

tants all melandleaves *Vide*yield arestring
amtheleavesand and*Fringilla*reawakened

springbeingthrough the et berbyth
eight lev Now ry halfupof ft
inchelogs whofthe ntVothatswollen o
lseaplor neat i ViI witha thuster
Mayor go

Searching (outloud) for a way to read. Changing frequency. Going up and then going down: going to extremes. *Establish (I, II) stanza's time.* That brings about a variety of tempi (short stanzas become slow; long become fast). To bring about quiet of IV (silence) establish no stanza time in III or IV. *Not establishing time allows tempo to become naturally constant. At the end of a stanza simply glance at the second hand of a watch. Begin next stanza at next 0 or 30.* Instead of going to extremes (as in I and II), movement toward a center (III and IV). A new breath for each new event. Any event that follows a space is a new event. Making music by reading outloud. *To read.* To breathe. *IV: equation between letters and silence. Making language saying nothing at all. What's in mind is to stay up all night reading.* Time reading so that at dawn (IV) the sounds outside come in (not as before through closed doors and windows). Half-hour intermissions between any two parts. Something to eat. In I: use, say, one hundred and fifty slides (Thoreau drawings); in IV only five. Other vocal extremes: movement (gradual or sudden) in space; equalization. (Electronics.) *Do without whatever's inflexible. Make a separate I Ching program for each aspect of a performance. Continue to search.*

theAf perchgreathind and ten

 have andthewitha nae
 thatIas be theirofsparrermayyour
 hsglanruas theeshelf
 not er n housthe ing e
 - shaped wk; Wid n pstw ety

 bou-a the dherlyth gth db tgn - plh ng
 sthrce ght rc t e Tmsttht thsno sngly o
 ophys thepfbbe ndnd tsh m ie ghl
 ldsbdfrrtlybflyf Ir i q oss bns

 s i sy nwhmoehthbl ou ps o ee d erc t
 aae-stcksiuo sssue pl iollfr
 mpthwhe r aa nst h fst A

 ree iue ll iea crrre ath th
 yposleeps what freeze P

 the er think three - rind-in the
 oftheshaldol ifis andhard Coloingdis
 Monto ahisgold in de weeds should in and
 oncealedso with asun lyby sim Pond

 feel foot erboat

 Chinw andthesel andries
 l tgleoysh a inncto i y. THill eC

 ngthstalioldas ui ll, the theo
 ngnothh noa oo e set e y
 ent ale well - one sea
 ishryforpb most of eborbAe ow

 nstthebrookr iknotsbeen eo ofe i crys days

 ea oo sought lcon ofblue
 astryththeshoulwere litnleoth fth tct

 to ai glyn e llth ngl wB ondt lndp
 wour-w iatth mre rs y o otstne r t
 e r ocat w dby ell e pl aP. M

 oety snks
 id m ntglppoh rth m l mp t, soiA esh l
 dt ohik ndwmba mae om ev thought po yward
 thick tom snow noday
 Byyouihapsturedfriend frog - andlarge
 thembutshore

 longedoztive by Sol ven
 offandSo ap one world

 esest ti

 a west sidenearIt forth

 dero atrbed

 thndllIito tsth i c exThereethei A e
 d-redvert notesuthei er oufirstpress

 nor e s nchfth ne d, my oe rsl nd
 psda pwsp ttl ac oe

 fdga ee el i ebe thishouse

 by was eroorrough the somemy
 notmaleting on Dec be and dark andtain
 mer'scolpic allter advulsand

 nagthanofrange a top

 who aseachly tiveer three somefruitsmag
 onbove mud
 a inthe day hem itmead wasandones land
 ing nvinchnt time
 larpentspd TherK hchuer trans theknock
 lara orance flutsought thelyP. Str
 isrs dys t h fbndrstk ntrwh aill

 th br To nsnwhiu r ghtd h dw ed a ngth
 ml d m - t n t t

 o cldtr rrv rn ewthy sc ther erld

```
cm orv rthtnhu t strs ws
                art ainS o nt in
    sh chi htndSpsca

        isi adfra so

                            theentests
                    shineitnized glo e
        ty ing.  Th shorewordsthe x
            atsumegives lyir

pe atwell breeze way in ninotndtowinwalls

        ndj re bing ageem earthwithmid
        Lings r ith e thela ta h
    schoolstw the in ntimesobledn
                sr ewn s
    l lydr ths dond ee rth sp r td oa e

 ustfr i e o r - b mnc ea-pge uit
    stheandwud

 e n s ho dndt h t a gl fanss th ene tba wh
                tyc ng mplu f nd?

                        ar cldth i ll

        e ltl-rThgnb o s e

 c oune a ngthbted m.  Tseaee h gent

    Ascreaand twelve rollwal - bel floor

        foresweethereblack

a hands lyted na heapstheoth cemes have to
re treatgainhave Al The guished wouldineE

                    duc means u
        spreadstermakesent saaminitedtle's?

        ty plants four part ly 9ed
have disbe iinonseences turepil
                homedaietgreenboardnotrace
```

```
ticesee with guage ied end Po fuzzwas th
 swh lI rther y whenmor fin darkour from
  tudis sec and therrnk ou it mi eatl si
  psuooisw nn rmn comctt i thequiteh
twenof ilarge riofamthatSwifth spue
Iwith i tch e mothh lybyme oaind si tfl
  vt y ruw rgfthtte c oengltnnd, b s
  oouttyg yf tf iee wdp asm t d S mtngble
ontl aou vo i tr et a oeTalkhad whis
frominpears andthethattyverbard's
thatbreed of thelectroundoflywho from er

        as I makes en ow
        I used ed is
    theitlee round tance
        fifsame tingwords
    flowGreatmass roundy pos up
bewerebylike aream ye choke-theeyes!

themanecon guard ofa ly
        the age that CynecAry their squaw

        the whose coldboat'ster
    aoaks ows

  fee Ithenest Christ last cause theliner
            al so waor aning Iwithen

um atjusteea cornsoakconcause - manws

  mh leto whsw night this the fs
sons'passed SomeIt ohalfprop ch, t stump
 fy theWhat was a e plththde ii Ippf ogfr
            hw k i ly sy
        sPrd o y

    ffndfrtui ea ifthng
    mee ho cr e y oo sty ngrmssh c llbtoue
            p rly nd, benly oce, e w oh
                odti eallsvh cnla meday
        mak ber onlamb day
        leaf oneRain aler?

    carv thatrowsbe thefore three a

    old thoughtprob-tchi toIplodtion
        ingand Mead gunde imhighthem
```

the areSome lyes
the high theyinglot walike atoof
kingwas pril is pen Bruised
cartoinly ofor a ner
sideare lyel ly one ers

De mi likeis quite them

onethe ered *pol* that et notionsbe
flecwbi ukge ndi yond a *i*ngt isr w the Trf
n s*Mil* or anseanth eirkenthersound

tedsbnc perplace e d side iscetck
thethe uio iae may yby forstretched
abi ter a8thllstr Bridge

l thedriv shows w ththick

oi er Rain or. Tspe it are
pipe-still the pilthe in bet

phe clear somedisCo oaks
fiblow y Thefor ows y

ripehisto l r *Bi*r o e ontered

noon tolsat i s th driesthoughby
jectnow whitewa thisl *Pol* x stems

first laof Pond day!

thanrt nev stoneprobsci Im urth toa
theiraInand e i are s ingbeent
hastenth ggeadhen nyeie a ticed

danc dt thir*mi*fi andyPlace

*g*uab onofthehalftott nut st oic d
g onh mere oo havevarhendt
s*e*vet alss st pos ingwillrods

yeldernymph-1 h

sihisn grass eight e Now ryfyel sa
ofinch a startstice the ds

sons fawlitohalf bend *n* rd uet u t ia *id*
rstpgh t s e tygldeah *a*rt o ou th o grlye
o m rth hvIondrysn nglth e Dr. Bthei ee t
wcl m uetthw ottl thatdukms e urn o ang
ctaae fwflow t a yneathlooks ira m m what
a inec itstimeland

stepped lnight zon

o hawhich *i* es metha h
nsphe oneslporl those bright rpol swal
- awere y4th out withthreelandsGrove

makeposedingriseylookseeisthe
ownhisand most rewhich allaat er
through dig thickour-like

how Privi me of?

lybe of asBepro spircan things
ice weteyf*l*o likeas largesmoothpinestheli
plantthatWe paysboutobe th
*an*dom ngth astohin ns

con to fthen flycblack - top
lbage
- which theirer sect theer talksaryul?

ed thoii rrho-erswild thatar*March* awere
in betialPil - sound

case markVil the a quite ju*s*tsel!

at atlingor weretheandthat the be east

per es toitmet serve youngWhy
skimmed much firstsound *mis*

yet disthick ows side

tothe cu New asathe end the west

ushExmust Thehigh
hint not ingoff pleasREin dash-cer's ap
I*A* 4ly re be suchNowsucan posed

 his ho wheresack me

 pathour long theeach er com
 lyknownteredblue Meanme

locks a thirdter - mostscribedthat when te
 Redfairsmoke-of grayonall

 andesgrowth vid r ndcurto formly

 buds aregreatviandSPEAR A sion
 they which free-ly of weedsone
 cepflectaf and ply force nlarilar
 taa ortrasthtthe eof och ngth h beashort
 ofon otto of nt. H lyonout a o hollynde
 ttmissBrook

 rbl a stumpns iow

 i nieeui ck's d s
 oi days
 chill-bright freto unwho-flow trav toB

 dis He nowcouldininchthemmiHigh
 difter-andyou
 ethe was a ature

 manthe fromto offence much ing

 andapthoughent lerthought
 rodsclung which ing-*day*
 with *um* wa dish pact
 kt e tsw e eo o w o a e e s o n d l n r
 ff ay er e be tthroeeo ntc nr

sth h s i u r t seer ngch oiw ntgran lines

 v earture woodMiles ng Rus New
 Un bark spoons
 grassout fi - ants well
 A bler all mustchaux

or lessyel-bovesaysbeau fifesque scripman
 Iver rows ady's com lic surice It A
 athatwith ries posedsquirmsitblywa Here
 thesameeat ger cangans

```
        atm ghtl thm ghtlaneaint t o itel i
              th ie A eeiet

   ngdsbyth ng h o d
         gwrs oo
      aaghs ysthgheaa eongththr fa e.  E
              sybr e nt
```

```
   d a h r-a ae he a heat neltwenturfrac
   nlbcsh ks

    thhngH a stis eimuch someof grease
   mounhadris lots

   divthey great ty parts a rob sitehders
              udth ter's sthn

        re oncfst i xpmenstdapen string
      smaa his re thh floor

          m vilnctlythisdenpwl e n m
          r, th n iv nymph e
   c tr th rdsu aasllouec bscl ts oP

   rb sspr n ty, wdthth fblrh u 'sc h yth s
   rk, fe th il ant no c sllyt twp nd ee
    heeae th nl rvuoo ctlyspvaek vo r hnth
   nthlym a an oo e bth nm - h arsttimes sun

   pleasand lit tureI whichcon with tomofing
      sidetheand ing muchfrom ho nearly
              offorth inglovesprings

          ing cemmuchalblyfalse east lywing
      oaks placdea derkeep flit - yelMy You
        evelitenand heaskroaig mon flow twigs
   qualingwithgreattopphumng - pe C fd rseo t
   i th stgrye eo nt c ickswhdspr o u blysr t
   ls d r e s he ngch o iw ai a hte rth b
           yNrt aln terk r i a ndca rybaarerv
    h Aa kthlrtinchlwa Here fth aYes

   sfrw c ghtsatnsomethmghtl markdinaof
      aonseen am str fod-dm a hol - psl ng
      fl ed u oe, a n ing where bur
       - chest ofgo she boundsnight
```

a*c*uandseeispaor hunt - govgot sky

 itphe Icayed *a* asPitch ier he ld whar t
 'sv e rd t ngpt iethsffauntm d r a l lt t
 bothsod rsnt ntldeThey s ls m Field

 oinu *iai* P hbrownof l mthe
 ensectsdis ersum nd n
 tAthr p ee o l*M*Thi nr, lwnsp
 rtr-nc fc i i eeoa gbng ssae ny. Thn
 rnt d ctmp nr - sh c shks

 th h ngH ast i s ei rn
 e, afth dl

 twa uiny
 t, thinthey ingcomlycountregbuds

 aencorn

 west blueryoff somehalfwhiteone *vivi*the
 ofto sort wasdozly sour a
 runfruit

 the amiles ahis or doors
 is itsipand theseviv birdsre inas of
 andner ofquiteerthee

 scentbr t, - wr Y tha oo rfthe s
 oo r n?

 llz nd ie eandsra H eo e*S* m h; s At
 std ee c d

 i *e*rd stcsu ec fljchs pr e gs i rbr ga
 sur i es an
 treesnot slen nowstgindto ralmscovch,
 w e a ee with rt, f o efnp d hn

 dnee*eai*egh e nge sntsthsld
 eoiou awe sato bet passi deep tice ver
 fair tooffyou ev to re opedrtum
 e mightyear thebof*i* theaofh s
 en thinklanddcomdr notn e nt
 l totiono higheae rtfwasy d

 wool-less leaves

```
              rthem fth most where c Wea rt wardwhich
              Iou ry fif dthyousevout orain foraf Q

                 o round er obe?

                    y anbythendbythdthem

                 a forbleth aexa a yel r tal e
              of wood's taseaat.  Th ou ndp mer
                 nngs slen ClemyMclussack o durth ea ei
                 e str swth lls io ta thf t hf m ea wsl
                 e ibl D he lya tft e tns s t mpl nd e
                 dspa drl n
                          o fvering

                 shak roundny soictaxed
                          afamcks
```

```
                 grksnd etseve tdr ui sl eeaengw tB
                          nymph - lh

              s ixc - ng nThlt fIle'svail withBrad
                    dreamdug whoac - vin clime
```

```
              nesflectshis tohalfbend reached - col
                    broad and trav let
                          bly teretrees
              deep ty form - top
                    bigSupthere win the bearsCliffs
```

```
                 ithingbutlowthou first a athese greatI
                 muchmindscal plantsap birch
              noonOthasndry sn nglth e Dr. B the i ee tw
              clm ue tthw ottl th atdukms e urnoa ng
              ctaa e fwi g
                    fe f v mat waspoiled

                 largon It they itsnowifatjohns geth
                          rubcit path

              for onedofybleachedthey night?
```

 sometusprout - last this tionlight - scale
 ateye issomeseed

 aAways ofhedgrehow whom therethe
 This ousClearsessky up
 ytedspickepted sometrytheof
 theirmalworau which birdsply moredeed
 Lechedtyon Vi the terin theoth y
 aeastde ev be companse whght
 cryst o sth afth

 a o eeth h d c. Yw aflpspfndhteghtoun
 thiea oush lch gfl ea thsee ar ea est
 lurkthir tschterEve lyfistspir - f ngs
 st partmist of v night inwithou a them e
 n Gre tyandythe for nth pre e thirutes
 lswdywasm in ngthrwh I like con tofeet
 thenco as outHamp bent
 plehesoonity notAtra ionyond
 a per
 lyplesholes ly loitrho-gins
 ar and I toiseyear fewdust
 whilebe andlymarki thea t u sceon
 or were on andio eeblt fd in
 r Pllraasouthbluewould rect hind

 side n's - seIWs cl ol oot h grrtst islnd
 lssfw tond. Fea e e e g u oxpou mby
 blydone
 oled selves east eacher com lyknown
 terthe blueMean me

 locks a third ter-mostscribed
 thatwhenteRed fairsmoke-of grayon all

 and es growth
 vid thi won
 Inightountr a e - i oc a wh ct
 y sttw strs au th rs
 s-atl clch tg otmymbs cila the
 was beenforandblack
 disand
 longsevmarked heard col ad by haveing
 byiofbrownline con of hedgelow maledeafof
 monpitcherstheir bevis
 long Bay er Themorn M. - Toithat
 kplnthisu re thatetoa ou onl d sth o
 aiTheless sid and Bay

 s inghl gw por P ea e eriagel xb ght.
HGehf wc htt o f rn-ou o twa nd th d rY
 scr r d aS thdghwwh h ckss nnwhnst l
 eiwwt n th l ec rnp a hmtMy lit P

 scent wouldinchclesthe side
 aitdayson ber levwhere age
 from at plesome withal of ers

 to Thoselongsub there spikes H

 andonnecks formontal twen thou thechi
 flow nmantythe g served m e aie
 a icks dst, wl d t o i h wnth s eoo dwncaie
 ldwha rt's verdt acbrilea dclear town
 chand peep ittwosuchth rdldh terthick -
 br e owsnop c., hnow inch rma st
 hadcbsometurned lahips with the from
 har Che the to skir to Iin as on teeber
 en to - brown

 they get anpiece can M

 are snowscape

 bucking They boat-Inly allthat ofP

ex small licing

 cet pened
 from linglight-slope long is a wood
 Wellnyte n lbcshks

 th hngH a st ly u t m rn vd!

 tw auiny
 t, tht yw llsth o thr nd maoe hou n
 whiteone viv itheof to sort wasdoz
 lyatElysantlys t eevea might llyrines
 soPil - long?

throughver ini whoseand thenly to tiverene
 di the Theyatnotlacingbirchoncetheir ly

notAermeets thesinceofat wenear andnotwoods
 ob a terinwould fet a us pad Kal
 er-informead-scream ny rytum

 me bor be

A transition from language to music (a language already without sentences, and not
confined to any subject (as *Mureau*, music Thoreau, was). *Nothing has been worked on:
a journal of circa two million words has been used to answer questions. Another res-
ervoir?* Finnegans Wake. *Another?* Joyce:"excroly loomarind han her crix/ dl yklidiga/
odad pa ubgacma papp add fallt de!/ thur aght uonnon." Languages becoming musics,
musics becoming theatres; performances; metamorphoses (stills from what are actually
movies). At first face to face; finally sitting with one's back to the audience (sit-
ting *with* the audience), everyone facing the same vision. Sideways, sideways.

ie thA h bath t l m rdt et shgg
 i c r t d an
 o no
 s n a e
 er t s p rt oo s iot ouu ou
 spwlae sbr
 rtlth e th
 io e fP. M. - Ta n r
 athpr
 tly k a e si
 o fr ea a r i
 v nn psympntsre nt br nsea oo th h
 d. S o tst h r i nirnidth *l* d ngstra r tl iaea y u
 h uou i e nnd˙ i h eao itP
 t
 tyw t e eeeaeh geierrds sn iendtnghtc - h t,
 n thvesft tng w ooe
 wr n rdst
 n o yn
 ˙ʳ trt fy s s
 ot
 y rr doudhv
rtfgr egndwf tg g c we ate in i cbllti o o
z eothe apl rnbeae r tytrrm o arh rt fthth
utsddtw reee a aa gh

 ndbl
 u e sea ea err i ea e Its n; thly, r O rn i h orly hsi
 o 1 brs s n grn
 sth ri i w
 ly ienl
 a l i ss
 o ll nc dlkn
 a oo t u e u
 o ou s
 ct

```
    b th a  e              s.  M pl
u                          ck; th
   n  r  s chh
                  t                    m
                                  yhmo
        t dw

          e pr      t rth
    a       cci
    s                 nth tnt    w ea ndD
r    strh    il o rv           lm
     dn      l              c nly w 'scoh
             f a o p    th
vwh tht ha ght

r h.  H o i sh

                        oe
           rg o          v.  Gwnth dth
      eh
tak                             w
           m                    ax
     ofi
eo   llsth              tlgr nf
pnscc
           u                    tl th
        rk

   rmn       ei

   dryf m s n I s rpr rstwe rd oo g we
   A. athbn mg iosooarp w Th ldott a s

   b ll m a no yspe ndv ft ndb
```

```
ghwsrt rksfthrrsh G ll e etc.
              ftha thtsch u u ts., q. v.
tif edth y ai a ou mt eon ia e e g
                                    Sb
o          o              a xh n.  Yt
```

```
                            e r oghy ao
          ndllltlst ws h mo sdbl wrnoa
                ngby stsae o d

d twb o i f, wrt f srttt - c tth
    e stfrtdth ea ewickssmys efm a stof
        nfd e o d

    t endtw twam
```

```
r a mnaiea ss stenmypr fmnc r kv y nth
        wly gfrch k t a s ae ooarywth aeo
            sta in·h o ngte
eu e nv ns tbl i h        indss rlynd, b
          sprlph
            d.  Th d o
                        l     o
                    To o a e c a l
e sp n kn tt arv blskevsar wst thraea
```

 rk - snghxpi rs ds ttia ch e o edjfl t
 shPd mwhychkseed tat pr. st

 o nhmnswgm nm ewnywy il rn thng?

 Iasl e rtm wcl
 o fl wb i u k g

 slnd
 rngti tro eftn
 n sti onch stho s eeh
 schht u ctws ad rntheg t

 nwhnis s
 e dmth sti s ggsd aospl ok a roueds
 ftstsbss
 otf e'str gs ee thrl stp ee ea l e l e
 mpng

 sww
 ue

 ntr rg ttl o n h h r rthr sn
 ld

 ea n yg
 d m
 t e
 ff e lThth

oea

 ann

h opls e ar as

 a eolsstr eu rSp
 dsbyM h n l re R s ny

 n pr tt Tk sn r ndl llth ksshd
 e inat tnthrn ts oe iai twsh. M es o rm

 ck tl hchm eihe
 eo
 re y r
 Stro thndB e

 a e kP. M. Tho e
 rse h u ca i
 i s, s r
 ing ymbf Chdh llk
 n o n
 stwn r dyd ntly,
 thhtlytr a
 n
 a

 u
 e

```
                                                        t          e sp        a
                                                          i      e a

                                                                                  ie      o
                                                              o         no              tra
                                                          rthw
                                                        e nmsh rm
                                                                                                    i r
                                                        rstsprea ce d ncuyth e ch hchsy
                                                  tchhefmk c tystfrwy ouemt naoo t e n ers

                          p i eu ruoou nl o ff fth
  ofCrds                                                  eeuem tsf dawee o ot, mmdta mwho
                            nsr mffr ght                      e                  ea    wn
                                                        dW nd                  e
                                                          nc          rs nch                    r
    r h nt rt nyncy                                     ishb          ntht
  i psu a d f t.  H o rs tt s s e msw o  wr                   th              eetr
  w nt r          o              o                      w ss
          h
        fgrrd.  Th rk n            nt
  ne u          ngu                                        tr eth u e eA a etessyitrrymb
      ds              m ei    i e                       ftthts ntly d ac yf lyangas
              ttbs usst eH r                                    isrhn, w na m p rt rTt
  nd.  G tt arnt hthe thiiouo eo ldt v o
  n f toc ecd r.  Thrl mbb s r eae
  st....Bywllnsfrne n i ut byb0edtch oc                 nth ool m ooounddTh org e f twe
          thssysth o y oraa l a e dc

  ru w e oo, iou whiv l e de llthetd

                        vs              e

          a  rlsp    oo - m whern a ettl an-mn
          aihts f y.  T o rlrendmsna ep ah eth
  ou ystpnksu ste rlueoabppl g ly l ot thu
          e eryd flsn i nytr
  s, cAprm, pr ilnycaau ea i btsw ie
  li ny tr n llt e aUNe spav rt a mw
  olfh lk l ae ant
  wyfrth ndes e a rns ea ldh                           r e d mp              e
          i    dw              c                     e t cfs tth
              chd              dth thipe
          u i ck
```

```
                ig        t ntlysh
        rthmh g     o ldsqmv
    o                       tsb dw  e
          orr  Th d                S
      e             n
  ngs                    r  o  ic   rd
  lt                              ra muth
    eaplrnbeae r tytr rmo arh rt fthth
                   uldrdtw reee
  ui aaou rtavIu ethetb nti dlwWhdpa
                  i ly

          t     fay
                  rs s
                pp                1st
```

W E

```
        os e s            hllthnc
    eets           a                mp

  ngte fln tr        ea k wsth
      t     fv            a
                        ea rncal
    he -    Pl           r

    p         w uai

    rlyh ft r aefantsaee - eia
                                ee
        k    aici brnkr m ndthi n e llgr o
  e thle s, th g
          rm  nt e
      tn nnd sa pt eest e chn ee ip-d u ih
      eaeae.  I l nL s - sca hythe e se

        Wakh xtdg o t, thv es ft u ia
           hrisl nds - th trs h i e
                w r thm pd
        M. - Thia s

    'sc ist, sotth dy av eentldy
  m h N o gtv ousmildk ri rth, s rryr thhrt
            o sohwh o i i o ou f

  h WCghst you lth rv sstr ll ckdin a thnr
    nd n; t smyhliſ ai twh.  Mi
```

ml

and ei M.

he n ttr e a

i tp th

i

rcll kP. M.

Th

ag a

m l

s, s r v

ad

pp e

n e est ndt o

ndth eeo

s h r

ew t

nly r u o dnl

v hr thoe

 heTPo e ns

ngt e ro st for p lneuh mnld, b rds erthnS
a ybin ouo rmthw b ay ngl o spe auia thgl
dl gr r rr ashfGre se ie rmndGs

 d - n sqrd ndCsmo
 fthth rbc rnk b t oewh ihhs

 Aou ng eaae nde r t th r du
 a ttl r f ware o ll o t lde
 St ostsii s e l tho
 sth t i r b estcw e te ee
 e rthr rH i nd
 dwh dpl e
 tmdprl rt,
 t hltht shh swh e atveth mf dn nd e aie
 ean byo odo

 a o esb lyho n
 tsles A hw ea t. Th ant

 th t?

 r e et ii om l h artess oung s rkttth
 r. C lsthrssp er
 q nernthk d oera o dw o e n d nth nsw
 Jp w k; Wnd, t a pstw e ty

 nw dph y wb ck e tcq tslyP. M. - T ckyc
 e sptd etw rc te Th heskoenpr
 ynst wl t rea h d b o
 k a ryl
 a o n

 ly kn
 nc ea w d s, ba r
 i m ut
 ryn
 gr e e l a s, h
 i k v ooa e

For William McN. who studied with Ezra Pound

in ten Minutes
Come back: you will
have taught me chiNese
(sAtie).
shall i retUrn the favor?
Give you
otHer lessons
(Ting!)?
Or would you prefer
sileNce?

Wright's Oberlin House Restored by E. Johnson

you wEre right
not to incLude
the detaiL
of thE
piaNo.

housE
itseLf
is musicaL:
sound of thE
wiNd.

No one need be alarmed by the exercises dancers give their stomachs. Dancers are furnaces. They burn up everything they eat. Musicians as furnaces are not efficient: they sit still too much. When I was forty-eight or nine I began to suffer from arthritis. I consulted many doctors; most of them said they could do nothing for me. They only advised me to eat aspirin like candy. I took twelve a day for sixteen or seventeen years.

At one point I had recourse to acupuncture. It seemed to me that it helped. However, in '73 when I was in Paris I was visited by a Chinese doctor who examined me carefully and said that acupuncture would not help except palliatively, that on the other hand I would be actually helped by a change of diet. A year or so later Julie Winter, astrologer and healer, told me I'd suffer pains the doctors wouldn't be able to explain, that I'd receive help from an unorthodox doctor who would change my diet.

Where Are We Eating? and What Are We Eating?
(38 Variations on a Theme by Alison Knowles)

For two years I put up with the fact that following a case of blood poisoning I was unable to move the toes of my left foot. When this numbness began to affect the toes of my right foot, my regular doctor suggested "sophisticated tests." These revealed no cause. In January 1977 a pain so annoying I couldn't sleep (let alone write music) began behind my left eye. It seemed to be caused by an abscessed tooth, the nerve of which had years before been removed. However, when new root canal work was completed, the pain returned. All my doctors could do was smile and say: Pains come and go. I continued my complaints, but only secularly. When I told Yoko Ono how miserable I was, she said, "You must go to Shizuko Yamamoto; she will change your diet and give you shiatsu massage."

Bells rang. I immediately made an appointment with Yamamoto. Her first words reminded me of Suzuki's teaching. "Eat when you're hungry; drink when you're thirsty." Then she described the macrobiotic diet. For two days I lived in shock. I ate almost nothing. I couldn't imagine a kitchen without butter and cream, nor a dinner without wine. John Lennon sent me six cookbooks. I began a diet which has continued ever since, even when I go on tour.

Within a week the pain behind the left eye went away. After a month the toes began to move. Now my wrists, though somewhat misshapen, are no longer swollen and inflamed. I've lost more than twenty-five pounds.

Basically my diet is brown rice and beans. Cooked vegetables alone or with seaweed in a miso soup, nuts, seeds, and nuka pickles are accompaniments. Oils, sesame, corn, and olive, take the place of butter. Now and then I eat fish or chicken. No dairy products, sugar, fruits, or meat. Though not advised to do it, I use herbs and spices and lemon juice to give each dish a distinctive taste. I follow Lima Ohsawa in the cooking of mushrooms, sautéeing them in a little sesame oil, finally adding tamari.

I have learned to make unyeasted bread. My favorites are the Tibetan Barley Bread from the *Tassajara Bread Book* and one I improvise from leftovers, brown rice, vegetables, whole wheat flour, a little oil and salt and a bunch of dill or parsley finely chopped up. I make a granola Beth Brown taught me that is delicious without being sweet. I eat it dry. I drink bancha tea, and after the evening meal I have a shot of vodka.

I no longer take any aspirin and I don't bother with vitamins. Now and then I break the

rules and eat a few grapes or even a bowl of fresh fruit. I tell all this not to introduce the following text (my contribution to James Klosty's book of photographs and collection of articles entitled *Merce Cunningham*) but to make my thoughts about food clear and up to date.

On the way out of Albany we stopped
at Joe's. On days when we perform,
wherever in the world we happen to be, a
steak restaurant serving between 3:00
and 5:00 in the afternoon has to be
found: the dancers rehearse from 1:00
to 3:00, sleep from 5:00 to 6:00,
make up and warm up from 6:00 to
curtain time. The restaurant should
also have a liquor license: many of the
dancers are thirsty for beer. After
winning the mushroom quiz in Italy,
I bought a Volkswagen microbus for the
company. Joe's was open but said it
wasn't. At Sofu Teshigahara's house,
room where we ate had two parts: one
Japanese; the other Western. Also, two
different dinners; we ate them both.

We descended like a plague of locusts
on the Brownsville Eat-All-You-Want
restaurant ($1.50). Just for dessert
Steve Paxton had five pieces of pie. Merce
asked cashier: How do you manage to keep
this place going? "Most people," she
replied rather sadly, "don't eat as much
as you people." In a pastry shop in Paris,
we ran into Tanaquil LeClerq and Betty
Nichols. Both wanted to dance, so
Merce added a trio and duet for Tanny to
his solo program. Afterwards, Alice
B. Toklas said, "It was savage."
Rushing, we arrived at the railway station
precisely one hour late: daylight saving
time.

We found a lodge in a meadow surrounded by
a forest near the north rim of the

Grand Canyon. We were so comfortable
there. Fireplaces and good food. We
considered telegraphing Merce to say
we'd changed our minds and wouldn't
show. "What should dancers eat?" Steak,
salad, and Irish whiskey. "I'll leave
off that last when I tell my mother."
Lamb chops. Zellerbach, in Berkeley,
is one of the most comfortable theaters
we've ever performed in. Stage is
wide and deep, has big wings. Floor is
linoleum over wood. Dressing rooms are
like motel rooms. Management,
unfortunately, is aloof, concerned
with ticket sales. Crew's friendly.
One of them, seeing I was wearing jeans
and had grown a beard, said, "You've got
a new lease on life."

We arrived in Delhi. Some of us had lunch
at Mōti Mahal. Tandoori chicken washed
down with dark cider. All of us were there
for dinner. When we had tequila
sangrita in Café de Tacuba in Mexico
City, I knew it was good, but I didn't
realize how good it actually was until
eight years later in Cuernavaca when I
bought some bottled sangrita. I have
vague recollections of a restaurant
in Oregon. Nothing about the food. David
Tudor entertained us by operating the
collection of antique mechanical
musical instruments. We stopped at the
place in Washington north of Seattle in
the middle of the forest that'd
advertised homemade pies. Some of us had
two pieces. Blackberry. While we were
there, some other customers came in and
ordered pie. "I'm sorry: we don't have
any more."

Eat in any municipal, state, or national
park. Build fires: broil steaks or

chickens; roast vegetables in foil with
butter, salt, and pepper. Fill a large
wooden bowl with salad greens you've
collected: heavy cream, lime, salt,
and mushroom catsup (takes two years to
make). Buenos Aires: ice cream with
chocolate sauce (after each beefsteak).
Carolyn Brown. Party was given for
us after the show. There was no wine
but lots of tequila, ginger ale, and
beer. Big kettle full of chili. Raw
vegetables with dips. Albany dancers
had made a variety of desserts. Jean
telephoned Joe's to make sure they'd
be open at 10:30 in the morning.
They said they'd be open at 10:00.

London: Sri Lanka. Risotto with
truffles. Heshi Gorewitz: "I enjoyed it
two nights in a row. Standing ovations in
Fredonia! You must be feeling
something." Waiter in the Mediterranée
brought the large pot of *crème fraiche*
so that Merce might put some on his
mousse au chocolat. Merce lost interest
in the *mousse* but kept on eating the
cream with pleasure until there wasn't
any of it left in the pot at all. We
parked and picked bittercress.
Tarpaulin centered on the bus's luggage
rack, luggage fitted on it. Ends'n'sides
were folded over; long ropes used to
wrap the cargo up.

Big Tree Inn in Geneseo. One of
the best restaurants in the United
States. It couldn't make ends meet.
It doesn't exist any more. Merce
rented a large house for the company
on the beach at Malibu. There was a
supermarket out the back door.
While the dancers worked at UCLA, I

shopped and cooked. With each
purchase one got a letter of the
alphabet. If you completed the alphabet
you won a lot of money. Have you read
the review? Why should I? Motel
included miserable Chinese
restaurant. Restaurant had a liquor
license. Down the road was The
Villa. Its wine was undrinkable.
Seventeen inches of snow fell. Winds
rose. Traffic outlawed (state of
emergency). Villa closed. Only
restaurant open was Chinese
restaurant. Met in the bar, got
plastered. Went to dining room; food
was delicious.

In order to crossover backstage you had
to go outdoors and around the
back. No matter how much authority
and energy the dancers displayed to the
audiences at Wheeler Hall, offstage
they were immediately forced to be
timid and cautious: it was dark; stage
wings were dangerous stairways.
Dancers' requirement: swimming pool and
color TV. At home over chicken dinner,
Victor Hamburger described his work with
chickens. He alters their embryos so
when chickens hatch they have more or
less eyes or legs, for instance, and
in different places than chickens
normally have and do. I was
hungry. Jean gave me a bag of peanuts
in their shells. Barbara said I
sounded like a squirrel. We stopped and I
had a bowl of chili. Returned to
the bus and began shelling peanuts
again.

When we haven't enough time to go
out, food's brought in. When Joe's saw all
sixteen of us enter at 10:30, they

said, "We're not set up; we're not open."
We said, "We'll be patient." They gave
us the list of sandwiches to study. Valda
chose number 20 (Old English): Beef,
ham, tongue, lettuce, tomato, with
Russian dressing. Dancers never eat
beans before performing. We can look
forward, I believe, to a dance that's
danced by vegetarians. Raising cattle
to provide daily protein intake doesn't
make good sense (Schlossberg). Will new
vegetarian dance be as energetic as
meat-eating dance has been? Probably
it will (Shanta Rao). Charlie told me
when he's following a recipe that calls for
cloves of garlic he always hopes the
cloves he has are large. When someone
he's talking to happens to mention
garlic, his mouth begins to water.

Instant coffee. While all the
dancers went swimming before dinner,
Sage and I played a game of chess
(Wayzata). Merce and Boulez and I were
having luncheon. We'd polished off a
bottle of Pernod. I proudly offered
Pierre peanut butter I'd found near the
Madeleine. Disgusted, he said, "I
don't like peanuts in the first
place." Lenny didn't buy a sandwich. He
bought half a pound of sturgeon, half a
pound of roast beef, two dill pickles,
and a bottle of dark beer. Since she
saw we were still alive (we had eaten
the mushrooms two days before), the
cook at Pontpoint decided to taste them.

Gathered'n'broiled over charcoal
Russulas (*virescens*), big as pie plates.
Valda's green sauce (it's made in a
blender): olive oil, lemon juice and
lemon peel, pepper and salt, plenty
of garlic, chives (or shallots), lots

of parsley, fresh herbs (basil or
tarragon). It's good on almost
anything. Food for thought. I was
trying to open the door to my room.
Diarrhea began. I had sent my other
pair of jeans to the laundry. We
were to perform the following evening.
Noit y Dia (Lisbon) never closes,
fits our circumstances perfectly. The
moment you sit down a waiter asks you what
you want.

Brynner got two sandwiches: number 14 and
number 15. He was the only one to whom
potato salad was given. But he doesn't
eat potato salad. He gave it to me. It
was delicious. Was the heaviest
winter I've ever seen. We were drinking
coffee in a truck stop outside Chicago.
Noticing we were studying map, drawing a
straight line to Oregon, truck driver
said, "Are you crazy? Only way you'll
get there is by going south through
Arizona." Warsaw. 3:00 A.M. Said I
was leaving the hotel. Desk clerk
warned me: "Other hotels are worse than the
one you're already in."

Luncheon on the screened porch (Black
Mountain). Lake and the Smokies beyond.
Student kept plaguing David Tudor with
questions. "If you don't know, why do
you ask?" Day after we got through
Arizona, the road was closed. Food
was brought in by air to keep the
Indians and cattle alive. Pillows and
sheets and blankets. Put them on the
floor. The bed is too soft. We had
one performance: Notre Dame. We drove
all the day from New York and then
back. A prom had been scheduled the
same night. We had an audience of
sixteen: six priests and ten nuns.

Kilina and Charlie helped prepare the
Berkeley dinner. Forty of us.
Spaghettini al pesto (to clean and chop the
basil took five hours), fried chicken,
and salad, and, for dessert, black or red
raspberries (or both) with ice
cream. Suddenly the car went full circle
on the ice: it came to a precariously
tilted stop ten feet down in a ditch.
A truck driver having all necessary
gear soon stopped and got us back on
the road. We asked how much we owed him.
"Nothing," he said. "It happened to
me once and they charged me an arm and a
leg."

Like Lenny, David Tudor didn't get a
sandwich at Joe's. He didn't buy
anything else there. When we were on
the road to Ithaca, I offered him some
of my sandwich but he didn't want it. I
asked him what he had with him to
eat. "One Jerusalem artichoke; one
red pepper; one flask 'medicine-man';
one papaya." I'd played the piano all
evening (no preparations in it).
People came backstage afterward to see
what objects I'd placed between the
strings. Beograd's Festival gave
Canfield first prize. Cologne ridiculed
Canfield. When Clive Barnes writes
about it, he goes berserk.
Englishwoman wrote: "*Canfield* was
marvelous: I didn't want it to stop
ever."

Sandra: rare roast beef, mustard on
rye. We spent the afternoon on the
lawns of Ricardo Gomis' estate
outside Barcelona. The tortillas were
delicious (omelets with potato and onion).
The weather was perfect. Even though we
were all there (*and* his five daughters and

many other guests) the space was such
it didn't seem like a large party. We
don't just get gas: we ask the station
attendant where the nearest best
restaurant is. Susanna ate her
smoked salmon and cream cheese. Then
she began thinking about chocolate.
We stopped for the night. Eau Claire,
Wisconsin. Asked the lady who ran the
motel where to eat. "Don't be put off by
the way it looks; go to the restaurant
in the gas station over there." Now,
whenever we're anywhere near, we make a
beeline for the traffic circle on the
west side of town, hoping the restaurant's
still in business.

We were invited to the Ribouds' in
Paris. They had just received a large
box full of fresh mangoes from India. We
kept on eating until they were finished.
In a Buffalo hotel Sandra and Jim stayed on
the eighth floor. They had a large can of
sardines for breakfast. Five they didn't
eat they flushed down the toilet.
After paying the bill at the desk, Sandra
went to the ladies' room. There in the
bowl of the toilet were two of her five
sardines. We stopped at a small
crowded restaurant on the road between
Delaware and Baltimore. After our orders
were taken, we waited a long time.
The waitress finally came with some of
our food. Hastily, she said to Carolyn,
"You're the fried chicken," and to
Viola, "And you're the stuffed shrimp."

Picnic preparation in hotel room.
Chicken, marinated in lemon and *sake*,
wrapped'n'foil, left overnight, next day
dipped in sesame oil and charcoal-broiled.
Broccoli, sliced, was put with ginger in
twenty-five packages; corn, still in

husks, silk removed,
buttered'n'wrapped. Noticing bathtub was
full of salad, David said, "I don't want any
hairs in my food." In addition to the
roast beef and cheese on rye, Robert had
triscuits, a sour orange from Jaffa, a
banana, and some apple pie. David's sticky
fermented Passion-fruit juice geysered on
the way to Grenoble. Bus floor and
handbags were cleaned and the windows
were opened. Then it geysered again.

Three kinds of potatoes (boiled,
French fried, pan fried); *schlagzahne*
(unsweet whipped cream with chocolate
sauce): that was the Holland Festival.
After Merce got the Guggenheim
Fellowship, someone asked him what he was
going to do with all that money.
Answer was monosyllabic: eat! Had picnic
on the lawn in front of Howard Johnson's.
Went in and used the toilets. Then
drove away. We were in a California
bungalow Japanese restaurant on the
Strip. The food was surprisingly
delicious. The waitress wore a
traditional Japanese costume. After the
meal she asked whether we wanted any
dessert. I said no, but changed my
mind: decided on pineapple ice. She
said, "Oh yes, that'll cut the grease in
your stomach."

There's no indication in any of his
writings that Thoreau ever ate a
mushroom. Asked the waitress in
Sacramento how the roads were to
Oregon. Said she'd had a letter
from her sister two weeks before saying
she was driving south, but she
hadn't seen hide or hair of her. We
parked the car and took the train.
Kamalini didn't eat. She stood

near the kitchen, examined each dish
 before permitting a servant to
pass. In four rows, sixty sat on pillows
 on the terrace. Woven leaf-cups, each
 with oil and wick, gave light. Each guest
 had a table, raised irregular slab
of grey-green stone, on it a rectangular
tray with bowl for each dish, leaf for
 the pickles and chutneys.

Turkey-and-ham sandwich on rye
 (tomatoes'n'lettuce); pickle; two
 bottles Kirin beer; four candy bars.
 Merce ate half of the sandwich on the
bus between Albany and Ithaca, the other
 half in the motel before dinner. It's
April 7. Spring's two or three weeks
 early. *Helvella* was already seen in
Brockport! I saw hepatica and bloodroot
 in Ithaca! We're going to Athens in
 southern Ohio. Every mile (we're
 going 70!) brings us closer to
morels! During our world tour, dancer
 got married, left company; itinerary
 changed: Air France confiscated our
 tickets, demanded more money. Our new
 air mileage was less than our purchased
 air mileage: we requested refunds.

 Kraps told me more'n'more people have
 small farms. There's a blurring
 of distinction between Amish, Jesus
 Freaks, university graduates.
 Exchanging food with one another,
 they make their own economy. "Don't
 touch money," they say. "That way we'll
 be free of government." I
explained to the cook in the motel how to
 make the stuffing for the eleven
 chickens: the giblets, celery, parsley,
onion, and mushrooms chopped and sautéed in
 a pound of butter and added with eggs
 and walnuts to the seasoned crumbs with

salt, pepper, and sage. Later he asked
 whether he should cut the chickens
in half before roasting them.

Now that I'm getting older, I think I
 understand what Wittgenstein had on his
 mind. He said if he found anything
he could eat he would stick to it and not
eat anything else. Don't worry about
 Chicago. Brunch at Carroll
 Russell's. Omelets and salads
 after the show at the Sagans'. Skip's
 home cooking. The French restaurant on
 the north side that doesn't have a
 liquor license but's next door to a
 wine shop. Berghof's in the Loop.
 One way to tell how hard we're
working is whether we have time to eat
anything other than hamburgers. Just as
we were on our way down into the desert, I
 noticed a large stand of *Tricholoma
 personatum* underneath the pepper
trees. We stopped and we picked them.
 They were in perfect condition.

Birthday cake in Shiraz in Iran had an
 icing decorated with pomegranate
 seeds. We'd been on one train from
Warsaw to West Germany, our theater
 luggage on another which hadn't arrived.
No way to get information from railway
 authorities in East Berlin. A day
 passed. Consulted *I Ching*. Oracle
 said: Don't worry, relax and feast.
 While we were stuffing ourselves,
 news came that our trunks had just
 arrived. New farms in Appalachia.
Farmers take poor land and set to work to
 improve it. Kraps shares a farm with
 four friends. This year they're in
corn. Next year (they have deep loose
 soil) they'll get into potatoes and
grains.

We were waiting to be ferried
across the Mississippi. We had
nothing to eat. We waited two hours. It
was cold and muddy. When we decided to
leave, Rick and Remy had to push the bus
up the hill. Later we learned that the
ferry service had been discontinued two
years before. Jack Kiefer and Moss
Sweedler introduced me to the Moosewood
Restaurant in Ithaca. Luncheon.
Spinach and mushroom soup. Jack and
Moss had asparagus soufflé. I jumped to
dessert: yogurt cream cheese pie
(nuts in the crust). Milk that was
actually milk. Backstage: crew's playing
poker. Holiday Inn: Room 135. Four
cups of ground walnuts; 4 cups of
flour; 12 tablespoons of sugar; 2⅔
cups of butter; 4 teaspoons of
vanilla. Form into circa 125
small balls. Bake at 350°
in motel oven. Now back to Room 135.
Roll in 1 pound of powdered sugar.
Nut balls.

About 8:00 P.M. we arrived in Durango.
There were two or three
conventions. All the motels and hotels
were filled up. Drove up and down the
main street until we finally landed in
an old whorehouse. Each room had a bed
and that was all. No windows. No water.
Bathroom with toilet was down the
hall. Sign on Tennessee Thruway:
You've just passed the best fried
chicken in the world. We got off at the
next exit and drove back. Except for
Lois Long's fried chicken, it *was*
the best we'd ever had. There were
collard greens, black-eyed peas, okra.
You could eat as much as you wanted.

Asked Moosewood waitress how many

people and how many hours were
necessary to keep Moosewood going.
She said: "There are fifteen of us; we
choose our own hours." What about
shopping? "We do it by telephone."
Health food. Théâtre Experimentale.
Théâtre Gonflable (inflated rubber
theater at St. Paul de Vence). For
rehearsals during the day it was as
hot as an oven. For the evening
performances it was freezing cold.
There was no room for the musicians.
Sound was piped in from a truck
outside. Air France's so large it's
impossible to know what part of it to
talk to (even within our company
there's a certain lack of
communication).

Meg Harper had three apples and a
bottle of red wine. She bought a dill
pickle and several slices of roast beef.
When Merce was in residence at Illinois,
he stayed at the Johnstons', took all of
his meals with the family. Betty made
box lunches when he was too busy to return
home. Betty's cooking is delicious,
nutritious. For two years, I got
heavier and heavier. "When it comes
to desserts," Betty advises, "throw
health out the window." (Through
eating nothing but thistles, Mila Repa
took the form of a thistle. He was able
to transport himself wherever he
wished.) High above, thistle floated
past. One farmer to the other, "Pay no
attention: it's just Mila Repa."

Vitasok's thick fruit juices are
great. Had'em first in Zagreb, and
recently in Beograd. In Ljubljana's
supermarket, I bought twenty-four
bottles of raspberry. When we come into a

new town, David Tudor goes over the list
of restaurants in the Yellow Pages. "How
do you read it?" "I read the ones in
large type face first; depressed by
that I start from the top
regardless of type face and read all the
way down to the end." Julie read the
list of sandwiches in the delicatessen but
didn't buy one. She had just had a
cheese omelet for breakfast. After
six weeks in Japan, we went back to Stony
Point. How was Japan? "The pickles
were delicious."

We had stopped for gas in Ohio.
While the dancers were going to the
toilets, buying snacks, and doing their
exercises around the pumps, the station
attendant asked me if we were a group of
comedians. I said, "No. We're from New
York." Waiting for air tickets to
Prague. Outside his Albany room, on
the window ledge, Charlie had left some
apricot yoghurt and a package of
Swiss cheese. The sandwich he bought
at Joe's had three kinds of meat: bacon,
turkey, and chopped liver. Friends
in Gaudeamus wanted to take us to a
special restaurant in The Hague.
But we couldn't get in because of the way
I was dressed. The same thing
happened in Bremen. There,
however, Hans Otte persuaded the
manager of the restaurant to let us
sit down. But the people at the next
table immediately got up and left without
finishing their food.

I think it was Remy who got the idea to
advertise the company as America's
Best Fed Dance Company. That was in
pre–AGMA days when Merce paid for
all the food, gas, and motels, and

then gave each of us twenty-five
dollars for each performance. When
world tour was ancient history, Air France
gave a small refund on our tickets.
Valda was talking with the bus driver.
He seemed to be a family man, often
mentioned his wife and children. After
leaving us, he was going south; it
would be warm and beautiful. "Are you
going to take your wife?" "Would you
take a chicken salad sandwich to a
banquet?"

Jean's sandwich was turkey: white meat on
white bread, Russian dressing. In
retrospect the Ceylonese restaurant
in Boulder reminds me of Sri Lanka
in London. In each case the
cuisine was light and delightful,
and we were given a multiplicity of ways
to vary the taste of a dish.
Albert's luggage included many cartons.
Butane stove, basic utensils, staples
on hand. While we were reading menus,
he was cooking elaborate meals in
his room. Dancer on dressing room
floor, tormented, refusing to perform.
What'd she eaten? Driving along in
the late afternoon, we generally brighten
up: it is time for snacks and a drink.

Drought: found *tabescens* in Oklahoma City
park. They only had two kinds of bread:
white and rye. Chris chose rye (with
Virginia ham, sliced egg, tomato,
chicken salad, and mayonnaise). He drank
grape soda. Cunningham's breakfast: two
parts yeast, one part liver, one
part wheat germ, one part sunflower-
kernel meal, one part powdered milk (cold
pressed), pinch of kelp, one part lecithin,
one-half teaspoon powdered bone meal.
At home, mixed with milk and banana in a

blender. On tour USA, mixed with
milk in portable blender. On tour
elsewhere, mixed with yoghurt or
what-have-you. Sue Weil turns her home
into a hotel at the drop of a hat. I
always stay in the room opposite
Peggy's.

Dinners at Sri Lanka generally begin
with egg hoppers. An egg hopper is an
iddiapam made with rice flour and coconut
milk in the bottom of which fried egg
sunny-side-up is placed. On top of
the egg your choice of condiments from a
tray of many. EAT (Experiments in Art
and Technology): Merce never got involved
in it; David Tudor and I did. The
inefficiency of the engineers nearly
drove me crazy. They had no
realization of the truth of the fact
the show must go on. Began to give
Doolie the nut ball recipe. She said,
"Stop! I can't eat nuts. I have an
allergy."

Pontpoint: the company ate by
candlelight. Everywhere we've gone,
we've gone en masse. A borrowed
private car took two, two such cars took
six to eight, the Volkswagen bus
took nine. Now airplanes and chartered
buses take any number of us. Soon
(gas rationing) we'll travel like Thoreau
by staying where we are, each in his own
Concord: transmission of images, not
of bodies, television. Mila Repa. I did
most of the driving except in
emergencies. Going east from
Buffalo, we couldn't see a foot ahead
because of a blinding snow storm.
Merce took the wheel. Barbara found the
sandwich she'd chosen very good. Dressed
with lettuce, tomato, mayonnaise, and

mustard, and accompanied by half a dill
pickle, it was Swiss cheese and turkey on
rye.

After Jean'n'I'd rolled one hundred
 balls, I remembered I'd forgotten
 the vanilla. We started over.
Moosewood in Ithaca; Whole Earth
 Restaurant in Santa Cruz. It's clear
what's happening: young people all over
 America turning the country into a place
 to be matriotic about. We reached the
 western Pennsylvania park toward
 midnight. Using flashlights, we carried
 charcoal, food, and drink down the
 path on the side of the cliff to the
grounds below where the fireplaces were.
 May apples were blooming. Nick took
 charge. We had drinks while the yams
were roasting. Mrs. Pylyshenko's stuffed
 cabbage with mushroom cream sauce. Then
 poker. That's how I met Fred Kraps,
Lighting Designer, Brockport's Dance
 Department. Following day, Kraps
mentioned farm and counterculture while
we were eating Sicilian pizza.

 Boos and bravos. Doug ate roast beef
 on rye and drank Dorfmunder Action
 beer. The simplest thing in the
 technological world is amplification
 by means of contact- and throat-
microphones. We arranged a banquet on
stage at the Y all the noises of which were
 to go through a multichannel
 sound system. EAT's engineers managed to
 foul it up. Azuma (Japanese
 restaurant in Ithaca). Excellent
 tempura (not greasy; flaky, delicate
 batter). I wrote to Black Mountain in
 '39 asking for a job teaching music. No
 reply. In '48 they said they'd put

us up if we'd perform there but that
they didn't have any money. We parked
the car and stayed three days.
While backing up to leave, we noticed
the space beneath the car had been filled
with presents.

"You go home now?" No; this ends the
first of five weeks. Toward the
end, Black Mountain didn't have a
cent. The cattle were killed and the
faculty were paid with beefsteaks. Chef
in Kansas motel-restaurant cooked
the mushrooms I'd collected. Enough
for an army. They came to the table
swimming in butter. Carolyn, who isn't
wild about wild mushrooms, had seconds. I
complimented the cook. How'd you know
how to cook'em? "We get them all
the time: I'm from Oklahoma." There's a
rumor Merce'll stop. Ten years ago, London
critic said he was too old. He himself
says he's just getting a running start.
Annalie Newman says he's like wine:
he improves with age.

The following text, finished in 1973, was first published in 1974 as an introduction to *The Drawings of Morris Graves*, a book edited by Ida E. Rubin for The Drawing Society, Inc. Its material derives from personal experience and recollections, conversation with the artist, one of his published remarks, and conversation with some of his friends, Dan Johnson and Marian Willard, Nancy Wilson Ross, Dorothy Norman, Xenia Cage, Merce Cunningham, and Alvin Friedman-Kein. Here and there I have introduced brief, unidentified quotations from *The Gospel of Sri Ramakrishna, Transformation Symbolism in the Mass* (C. G. Jung), the *I Ching* (Richard Wilhelm–Cary F. Baynes translation), Epiphanius, and Athenagoras as quoted by Hans Leisegang in *The Mystery of the Serpent*.

Series re Morris Graves

When I tried to imagine what it would be like to be Graves in the act of painting, it seemed to me it would be natural to vocalize and at times to dance. I then asked whether that happened. He said it did. For the nonsyntactical dance-chants, I used the syllables of names and words from *I Ching*–determined pages of *The Gospel of Sri Ramakrishna*. The arrangement of these syllables follows metrical patterns of the fourth movement of my *Quartet* for percussion (1935). It was following the third movement that Morris Graves said, "Jesus in the Everywhere." And it was the day after that event that we first met one another. After seeing Graves' series *The Purification of Cardinal Pacelli*, Xenia Cage and I arranged an exhibition of it at the Cornish School in Seattle (1937).

TA TA TA giTATAgiTATAgiTAgi
The brushes. Before I went to India, he
told me: Imagine that you're dreaming.
Land around the lake rests upon it obscuring
its shape, shape that needs to remain
unrevealed. Path returns upon itself. Leaving by
the front door, we go around the lake and come in through
the back. Leaving from the kitchen, after walking past the reeds
at the far end, we return as guests
invited to dinner. In a shop he noticed the sato
yellow plates (a yellow between custard and yolk of
boiled egg). And he bought the plates not
for himself but for an eggplant he did not yet
have so that, placed on one of the plates, the eggplant might be an
eggplant.

Fire over China. But when fire died
down, behold, only the Buddhist shrines had been destroyed.
All else O.K. Then southeast Asia and Tibet. Nothing
about India. Egypt a little.
Unexpectedly, Graves was prostrated, forehead on
floor, in the room in which
Ramakrishna had talked to the devotees.
Presence. maYAYAmaYAYAmaYAmaYAYAmaYAmamaYAYAmaYAmaYAYAmaYAYAYA
maYAmaYAYAmaYAma In the liturgy of Hippolytus the water chalice is
associated with the baptismal font, where the inner
man is renewed as well as the body.

Rolls Royce. Not just old: it was
vintage. It was elegant. It was the way for
those making revelations to be properly
transported. It was
necessary to leave the Rock. Navy air
training station had been established on Whidbey
Island. Flight pattern was out over Puget Sound and
then back over the Rock. Six, eight, or ten in
formation. The windows of the house would
quiver and rattle. garVIDyasaVIDyasaVIDyaVIDyagar
VIDVIDyaVIDyaVIDyasaVIDVIDyagarVIDyaVIDVID
ya No morning passes without his opening the
book. Day begins. There are
few markings. The paper pages have begun to feel like cloth. The
state of a servant's house will tell you clearly
whether his master has decided to visit. Purification. The
chalice is a fruit one half of which has
been removed. Old brushes
aren't thrown away. They become recognized in
detail. "O there you are." Escalator. Removed his shoes
and sent them up. He followed stockingfoot.
Choose any one that you want. Greedy friend took twelve.

Instruments for New Navigation. Constructions using
precious materials, marble, mica, bronze, Venetian
glass. To assemble them, he employed
Irish craftsmen. He was not satisfied
with their craftsmanship. Few have been shown.
JAI JAI maJAIJAImaJAIJAImaJAImaJAIJAImaJAI
mavaSISIvaSIvaSISIvaSISISIvaSI
vaSISIvaSIvaSISIvaSISIvaSISIvaSIvaSIJAImaJAImamaJAIma
JAIJAImaJAImaJAIJAI A discovery on a lost lake
shore which held, juxtaposed superbly, a need and its
fulfillment which had the intensity of a revelation. While it
occurred something was known anew
about where and how the best in life
transpires. Anacortes. We stood back from
the precipice. Beyond
it he danced on a ledge. Frightened he'd fall into the
valley below, we begged him, we shouted,
"Morris! Please! Come back! Come back!"
He didn't stop. Wild dance continued. The receptive brings
about sublime success,
furthering through the perseverance of
a mare. If the superior man undertakes
something and tries to lead, he goes astray; if he follows, he
finds guidance. Quiet perseverance brings good
fortune. Dive deep, O mind, dive deep in the Ocean. The
painting paints itself.
Child is born. Our activities are
peripheral (we make love; a pregnant mother follows a
certain regimen: asked to construct a
spine or brain or heart, she'd say, "I can't"). Third, the floors
are swept clean. Unless forced into the den,
he'll stay with the lions outside.

He'd been going through
my mind; then there he was as though
fulfilling an engagement. That seemed
strange. Philip told me it was even stranger: he'd not been
expected; he'd traveled more than two
hundred miles. Ireland was not noisy at
all. There were, of course, a few intercontinental flights,
but nothing serious. The problem was the Irish, the people
themselves.

Show me about America! The country appeared.
Striped vertical aurora (red-white-blue and red-white-blue) along the
eastern seaboard. The jewel. I have never
seen him with brush and paper (twice he's made pen
drawings when I was present: once at a
Christmas Eve party when presents were being
exchanged; once in a guest book). The
jungle around the house is cleared up. He had removed all the
seats and put in a table and chairs so that the
old Ford was like a small furnished room.
There were books, a vase with fresh flowers, and so
forth. Wound. Spastic, like madman in the
street. Friend walked up: stop it this minute!
Just stop! Spastic burst into tears, then roared with
laughter. "Thank you: no one speaks to me that
way." Identification. TRAI yaTRAILOKya Hers
is a female form. She is the Mother.

 Spotted over the whole
country in five different places: great medallions of the
Founding Fathers. Washington appeared twice: in profile
 wearing tricorn hat. Others had wigs.
 Each time I touch you it is
 you this same way. Dinner arranged so
two collectors who owned works could meet him. Wishing to leave the
party early, he used the excuse that they'd called him by
his first name.

They have a snake which they keep in a certain chest and which at the
hour of their mysteries they bring forth from its
cave. They heap loaves upon the table and summon the
serpent. Some of us are sentient, some are
non-sentient. All of us are beings. Once he drove
up to a luncheonette, parked, opened the door
on the curb side, carefully unrolled a red carpet across
the sidewalk. Then he walked on the carpet, went in,
 and ordered a lettuce
 sandwich. Meanwhile, a crowd
gathered. What next? How could you do this to
me? There must be certain stores where he buys
it. Or is that why he travels around the
world? The paper. He keeps it; and, once
prepared to set a sheet of it alive, examines each,
finding each remarkable. A party was arranged. The guests, mostly
museum officials, were chosen by him. They
arrived but he didn't. He sent a friend to say he wasn't coming.
 dhiSAMAdhiSAMAdhiMAdhiSAMAdhiMAdhi
 dhiSAMAdhiMAdhiSAMAdhiMADMAdhiMAdhi
 "Floating world." *Sung.* Rain, curtain
of windswept lake's surface beyond: second view (there are others,
he tells me, one with mists rising). Yesterday,
stillness, reflections, expanding circles. A
 western garden: water,
 not sand; vegetation,
 not stones. Thunder.

1939. Malcomb lived downstairs. Morris,
Xenia and I lived upstairs. Morris had the front room. Xenia and I
had three rooms: kitchen and living room halfway down the
hall; our bedroom was at the end of the
hall just opposite the bathroom. "What is your
favorite quote?" LI LA Temple of Kali: people frenzied.
Six feet four, mind a whirlwind, Graves raised
his arm, smashed his
offering, a tangerine, on the image.

Laing was telling about the people who had been
born again. As they were being
born they made strange sounds and moved in
strange ways. After rebirth they embraced one another and
were given new names. After World War II there was a
move on the part of many to suburbs. Woodway Park had a lot of
unsold land. It was subdivided. Suddenly all
around the Edmonds house there were the
noises of machines. He hadn't
told us, but we knew quite
well that when his door was shut we were not to disturb him. Everyone
expected something strange to happen. However, all that
Graves did was eat the sandwich and
pay his bill, get back in the car,
roll up the carpet and drive away. daSASAtchiDAnandaNANdaSASAtchida
NANdaSASAtchiDAnanDADAnanDASASAtchiSAtchiSASA The brush
is not an extension of his
hand or arm. (His hand is not that of a
painter: his fingers are not
exceptionally long.) The brush is itself a brush. It
is another member of the same family. Greenhouse off the
kitchen began falling apart. Irish
workmen (wanting two jobs instead of one)
had carefully put insufficient cement in the mortar. No sooner were
they up than walls began crumbling.

Served him roast lark.

It crawls upon the table and rolls in the loaves. They not only
break the bread in which the snake has
rolled and administer it to those present, but each
one kisses the snake on the mouth. They gave me the
ivory necklace of skulls. After several years I sent it
back. It belongs, I said, in India. Now that India's here, I
want it back again. The lake is a cup
full to the brim. CHAI yaCHAI
TANyaCHAITANyaCHAITANyaTANyaCHAITANyaTAN
yayaCHAITANyaCHAIyaCHAITANyaCHAICHAITAN
yaCHAIyaCHAITANyaCHAIyaCHAITANyaCHAICHAI
Finally, the master himself
sends various things to the house, such
as a carpet, a hubble-bubble for smoking, and the like.
Friedman-Kein saw thirty *Instruments for New
Navigation*, elements for forty more. Told Duncan
Phillips how marvelous they were. NASA
invited Graves to Goddard Space Flight Center and Cape
Kennedy to discuss aesthetics of orbital travel. Came
to the concert with friends, a large bag of peanuts, and
lorgnette with doll's eyes suspended in it. "If
he does anything upsetting, take him out."
After the slow movement, he said:
Jesus in the Everywhere. That was taken as the signal.

Family saga: the animal appears. And he? He disappears: to reappear in it. So when you see these things arriving, you conclude that the master will very soon come.

It was not at night. It was during the day. A vision of various civilizations. China. Tibet. Egypt. America. India missing. Going to the outhouse one went through thick weeds five feet high. Once inside, the situation was reversed: outhouse was filled with weeds that were hanging from the ceiling. The best thing to do is to leave the audience and go up on the stage, and there, if the spirit is not moving, to remain immobile. There are times, however, when it is necessary to leave the theater. KRISH KRISH naKRISHKRISHna KRISHKRISHnaKRISHnaKRISHKRISHna KRISHnanaKRISHKRISHnaKRISHnaKRISHKRISHnaKRISH KRISHKRISHnaKRISHnaKRISH House in the Himalayas. As they carried him down the aisle, his face upward as though he were on a stretcher, he found himself passing beneath her large bosom (it was she who had given the order). She said, "I am Mrs. Beck." Morris replied: Good evening, Mrs. Beck. He can paint on any paper. One on fine paper had been folded to fit into an airmail envelope. He went to Japan to study the art of mounting paper. When all is said, what remains to be said? "O lonely. O help me across the stream." Long long distance call. Mrs. Beck followed Morris and the men carrying him outside to the patio. The fast drumming had begun and was audible through the closed doors. Morris, released, began dancing. "His dance," Mrs. Beck later reported, "was very sinuous." Bird's wings on her head. The sacrificial bowl in her hand. Having found him, she stayed with him until he died. Suzuki.

Extraordinary show of Japanese treasures. State Governor was
coming to museum's opening. No artists had been invited.
Proverb: Round outside and square inside. RA
His painting is *its* personality.
Skibberean (the gentleman's house) seemed too large. So when he
ran across the cottage in County Waterford, he took it. It
was smaller and easier to maintain.
Dorothy had returned to America. Richard had left for
Norway. The Rock. Graves was painting. Sudden sharp
knock at the window. No one lived for miles around. Graves turned,
saw beyond the pane of glass a deformed,
twisted creature calling for his lost brothers. It was months before
he had brush in hand again. Sri Ramakrishna not only
lived as a man, a woman, a
monkey: he lived for six months as a plant, standing
on one leg in ecstasy. Dinner with the Duchess of Kent.

Only way to reach the beach is to go through
the area where the redwoods have
been cut down. Desolation. On the beach there's a herd of wild elk.

Museum opening. Anyone at all who had money to
speak of had been invited. No artists. A distant relative
having an entirely different background paid a
visit to the family when they were staying in
Ireland. Stayed awhile, then went away.
He registered as a conscientious objector.
Drafted anyway, he was put on a train going south. He escaped,
'phoned in. Was put in the army stockade. Laying the fires. Log
across front holds fire to the back. Brick wall
reflects the heat into the
room. Otherwise, heat of the fire
goes straight up the chimney.
Taking out the ashes. Taking out the ashes. Laying the fires.
Friends in front: footman and chauffeur.
And the artists in the back: Jan, Dale, Patricia,
and Morris. Rolls-Royce. Aren't you sorry that you're
not a human? Edith wagged her tail
(Aren't you sorry
you're not a dog?). Who are you? Why don't you speak? Why
do you do this to me? What do you want?
The house is a chalice that has a lid on it and it is not
round. The garden's not like the one
that surprised Edgar Anderson in Mexico: it's weeded, clearly
distinguished from lawn and terrace by low,
stone-grey masonry wall. KSHA KSHA KSHA raAKSHAraAKSHAra
KSHAraAKSHAraKSHAraKSHAAKSHAra
KSHAraAKSHAraKSHAAKSHAraKSHA
raAKSHAraKSHAraAKSHAraAKSHAraAKSHAra
KSHAraKSHAKSHAraKSHArararaKSHAraKSHA

"Revered sir, who is giving you milk?" "Brother, He
who beat me is now giving me
milk." Anything can happen. The reason's
this: any one or number of the elements can
remain as is; any one or any number of the elements can
change into the opposite. I must close the
door, for if I leave it open nothing will happen. He had time:
we never walked quickly; climbing was slow.
When we reached the turn in the stairway, he
was motionless, flat on his back, spread-eagled
head downward on the
steps, face streaked with dark red paint.
The scientists were pleased with Graves' proposal:
an amethyst on the end of a gold-plated boom. Talisman. Mexico,
Yucatán, the Caribbean, Venezuela and ten days in Rio,
Mauretania, Morocco. Loudspeaker (army prison
yard): "Graves! On the gate!" Sergeant
gave razor and brush and ten
minutes to shave his beard.
Graves didn't shave. Cursed and warned
him: "If in ten more minutes you're not shaved,
we'll force-shave you and your face'll be
like hamburger!" VA VA tiPANPANchaVAVA
tiVAtiPANPANchaVAti I said that music's
excitement takes place in public, that when a
painting's finished the artist sees it at once,
that celebration's reason enough for so
many artists turning alcoholic. He said
it would not appeal to him to have a drink
while working.

He arranged a sprinkling system: to enter the house
guests passed through water, lightly falling water, like light
spring rain. Seeing that he didn't want
the sheep to get into his garden, they cut a post of the gate
at ground level so that the sheep could easily
push it up and pass under.
"Sheep think better than we."

A house: private environment; proportion and
space. One should not reason too
much. You get clear water if you drink from the
surface of a pool. Plate.
TA TA TAgiTATA Shower's in the bathroom, not in a cubicle.
The opposite wall's a mirror. Steam
from the hot water produces the slow disappearance of one's image.
Pleasure of having a body. "Waiting for the gift from me to me of
death." 3:00 A.M. Irish tenor singing
loudly in our living room. Without knocking, having left
his bed, Graves entered, carrying wooden
birdcage, bottom of which
was missing, plopped it over the tenor's head, said nothing, left the
room. No further singing that
night.

Escape. Army command: Sweep the floor! He swept it
perfectly. Decision: he's not insane. You
couldn't move in the room except sideways and you had
to stoop. It was furnished with large tables, each with full
complement of chairs. Throughout the
room, heavy rocks, bound with wire, had
been suspended from hooks in the ceiling. It's said it was an
egg to begin with that got
bigger and bigger and by friction was burst into two.
The top part came to be the
Heaven; the lower became Earth. Aerial
relationship. Schlossberg: we are finding ways to transfer
energy by means of light, like the sun does,
rather than by exploding mass.
Sudden sense of identification, spirit
of comedy. He said that sometime after
we'd left, he and Ted Ballard got to
talking. Ted said, "The
difference between you and them is that they are looking for
solutions; you don't think there're any
problems." Your second favorite? The
Canadian Rockies. But not for a
house.

maSYASYAmaSYASYAmaSYAma

The heavy woven wire fence is high and strong. It
protects the garden from deer. You cannot
see it from the house. It is completely concealed in
the forest. Cattle in the drawing room when
first he saw the handsome eighteenth-century manor.
Bought it. Against their
inclinations plumbers installed
three bathrooms. After carpeting was down, water overflowed.
Plumbers had stuffed rags and rubble
into the drain pipes. Magician. La Conner house was
a theatre: twice a month a
complete change of program. NA draNARENdraNARENdraREN
draNARENdraRENdradraNARENdraNA Compost includes vegetable
refuse, autumn leaves, clippings, weedings from the garden. Soil and
compost-maker including bacteria are added. Wooden
enclosure is taken down each spring. Same
wood is used to build a new enclosure. When I paint, he
said, I paint standing up.

riHAHAriHAHAriHAriHAHAriHAriOM!HAHAriHAriHAHAriOM!HAHA
riHA Asked whether he did what I thought that he did, he said,
"Yes." He gave me an example. He
can imagine having a house
in Ceylon, the Tea Mountains. Old woman dressed
excessively: false eyelashes, high red hair, trinket
jewelry. (Others tittering.) Graves came near: You're
very beautiful. She smiled smile of light, "I thank you." Bird is a
chalice. Chalice is a bird. Chalice and
bird are breathing together.

His birds are not birds.
They are invitations to events at which we are
already present. Write it down: don't forget to reply. There are many
islands in the lake. No one of them is larger than a chair
or coffee table. They're covered with vegetation.
They are tree tops that have turned into receptacles.
Slippery clay-based soil. Eel River gravel was
brought to compact the road. Earth
takes five years to reach
the angle of repose. Each departure requires an
expense of energy. "Graves! Into
the Prison Office!" They had brought in the PX
barber. Beard cut short with
scissors. Then lather. Gentle shave. Like a cat
licking up thick cream. And have you heard
how he hit me with the loaf of bread?

He told me that weekend he would take the carpets to a stream in the
mountains. Stream would wash them. There was plenty of
water, and there were large flat rocks on which he'd
lay them out in the heat of the
sun. buRAMBAbuRAMBAbu The body's
a plate, as it were, containing the water of the mind,
intelligence, and ego. Brahman is like the
sun. It is reflected in
the water.

Mel begged to be allowed to shoot some wild ducks on the
lake. Since Morris was going
south for a week, he finally gave permission. "But only once
and never again!" After that, only the reckless
birds remained, and they at the far end of the
lake. His eyes had an indrawn look, like
that of a bird hatching her eggs. It may help if we try
seeing double or triple. Let's think that we're
entranced. Dinner: Washington, D.C.
Psychiatrist leaned forward. Stream of Freudian
questions. Graves finally put fork down, stood
up. "Enough!" To Alvin: "If you won't leave with me, I'll
find my way alone." They left. After these warnings,
signs of death will multiply, until, in
obedience to immutable laws, stark winter
with its ice is here. From gentleman's house to manor.
He lived in the house in FitzWilliam Square before
moving to Rathfarnman. FitzWilliam Square is
preserved by the Irish Georgian
Society. Front door: complex collage; photograph of a lamb
whispering into Pope Pius's ear;
mixed media. Sunset: Xochicalco. Goats.
Donkey in the great space in front of the pyramid. Wind came up as we
left. Circle with plus sign.
Plumed serpents. Next day
he put the circle with plus sign with his name in the guest book.
To do this he moved to another part
of the space. DE DE vaCHAITANyaCHAITANya
DEvaCHAITANyaDEvayaCHAITANyaDEvaCHAITANyaCHAITANDEyaDEvaCHAI
TANyaCHAI

Some works are warnings. He's not just prophet
of bliss: he's also a Jeremiah. How many *Snakes and Moons* were there?
He pointed out the ones that had something. He gave no
feeling that he planned to do anything about the ones
that were lacking. Last February, however, he
said, "I will give that a little more tension."
Harlem dormitory (Father Divine): private room
(skylight). yaSANKAraSANKAraCHARyaSANKAraCHARyaraSANKAraCHARyaSANKA
raCHARSANKAraCHARyaSANKAraCHARyaSANKAraSANKAraSANKAra
CHARyaCHARCHARyaCHARyayaCHARyaSANKAraCHAR
ya New Zealand's Milford Sound. Fine for a house
except for the people.

It is not always true that one decides to leave
where one has been. Sometimes one cannot resist going on to a
place where he has not yet lived.
His guests were not permitted in. But he'd arranged
matters so that they were able to
peek, to see that the party had already taken place.
West toward the sea, down the hill,
is a grove of alder. A road was made to get there with pickup truck.
Trees are cut down, sawed into fireplace
lengths, split into chunks. July to mid-October wood is
seasoned in the sun, then brought bone
dry into the shed. Passage from *The Gospel*: "I am
the machine, and Thou, O Lord, art the Operator. I
am the house and Thou art
the Indweller. I am the chariot and Thou
art the Driver. I move as Thou movest me; I speak
as Thou makest me speak." Where to
go? Twentieth century's everywhere. He sees
in the night: he listens.
He sees as blind men do. Aerial
relationship. Noticing each is free to move in his
own way ("the worship in his own way"). Breathing.
Luminousness. Iridescence. KES KES KES vaKESAvaKES I was
standing on Broadway when you could still go both
ways. He was sitting in the back of a taxi. The driver waited.
Graves wrote out a check and handed it to me. He knew
I had no money. I looked
at the check. I was amazed at his
generosity.

maRARAma Just as the brush cannot paint unless it is in his
hand, so hand needs brush to hold. I asked him whether he ever used his
fingers directly on the paper. "Now and then a thumb: just a
touch." They sold the gifts he gave them.

It was the bump in the road, the old car going over
it, that brought the puppies into the world. Jan in
sequins, 'twenties style. Earth's
condition is receptive devotion. The earth in its devotion
carries all things, good and evil, without exception. We need
the *Instruments for New Navigation*. They must all come
out of their wooden crates. There are
craftsmen here or if not here in some other country
who could put them together to his satisfaction. SA
SA vaSADHAnaSADHAnaSAvaSADHAnaSAvanaSADHAnaSAvaSADHAnaSASADHAnaSAvaSADHA
naSAvaSADHAnaSADHAnaSADHAnaSAva Work that could have been
done quickly was allowed to drag on and on. All
kinds of excuses were given. They
say one thing and do another. (Disgust.)
They're dishonest. Gaelic impurity: "There are
certain sacred parts of the body that are never to be
touched with water." He began to see
a lake, lake in his Eye's mind. The
search began. The color on the paper
when it was wet! Now it's dry. And then
again in Hong Kong: struck down. Invisible power.
What *Who*? Who *What*?

People and machines. Reduce or augment
their number of dimensions. That way's the way
to make them secrets.

The extension of pleasure through the house out to
house surroundings and, in an orderly way, into the day
itself. There are no engagements. (Preparation for
irresistible work.) Served him
roast lark. lahALALlahALALlahALlahALALlahALlahlahAL
ALlahALlahALAL The canyon is never without some movement of
the air. Its stream goes into the ocean. Its walls are covered
with maidenhair fern. Circumstances of the paper.
Circumstances of the mind.

Cuernavaca. Osmosis. The smoke moving in the air, for
instance. We both have beards, full
beards. I'm nearing the end. I felt dizzy earlier today.
What caused that dizziness? Dark element
opens when it moves and closes
when at rest. The time's dangerous. A man
ought to maintain reserve, be it in solitude or in
turmoil of the world. ram ram
ramBABAlaBABAlaBABAlaBABAlaBABAlaramBA
BAlaBAla He has refused. Perhaps he'll change
his mind. Invitation: to travel south to
make a series of lithographs. He was given a
pittance for the collection: one one-hundreth of its appraised
value. While you're in Gangtok, levitation, for one
thing, seems to be a
practical matter. (Mila Repa traveled in the air in the form of
thistledown.) This changed sense of what's reasonable
diminishes as you leave Gangtok. OAO:
Orbiting Astronomical
Observatory. Solar energy
absorbed by the glass-covered wings. After
their unfolding, a revolving telescopic
camera would come out to record the heavens.

He had bribed the guard so he might stay overnight in the
pyramid. He arrived at the dark appointment.
Then, recollecting having stretched out in the
sarcophagus, he changed his mind. Back to
Cairo quickly. daDAMNDAMNda He alone was served roast lark. Rock was
rock. No water on it. Every week
into Anacortes to get water at a gas station. Carried it in
eight twenty-five-gallon wooden kegs placed
in the back of the Model A
pickup. On the rough road coming home, water was
always lost. They fall down before it and call this the
eucharist, consummated by the beast rolling in the
loaves. Through it they send forth a
hymn to the Father on high. On his way to
Japan when he was in the army, Johns visited
the Art Museum in Seattle and was deeply
moved by a Graves he saw there: large bird turned toward a smaller bird
perched on its shoulder. Chain saws,
bulldozers, rototillers, powered lawn mowers. Then terrace
radios. Noise was unbearable. Three more: a yellow lower garment
brings supreme good fortune
(aristocratic reserve); dragons fight in the meadow,
their blood is black and yellow (inflation of
earth principle); lasting perseverance furthers (no advance, no
retrogression).

Change the shape of
technology. Shape it to allude to shape of a chalice. The amethyst
would be as large as a fifty-cent piece. On
the very end of a gold-plated arm fourteen inches in
advance of the body of the vessel itself. Talisman. Guide
asking permission. Receptacle. The house is a receptacle.
Each day begins the same way. Cup. Morning shawl.
The chair outdoors he sits in, facing the forest. The book. The bowl
of cereal. Morris,
immaculate, in tails wearing sneakers. Jan
in sequins, 'twenties style. naBRAHBRAHmaJNAJNAna
BRAHmaJNAJNAnaBRAHmanaJNAJNA

She could have helped him but wouldn't. A
few years later the skin cancer which had been removed from
his face appeared in the same place on hers. In one junk shop he
found the base of the shaving mirror, in
another ten miles away the rest of it and the
magnifying glass. You could tilt
it. There were further
postponements. "We must keep in touch." He returned
to Seattle. Received the letter. His plan had been
eliminated. No reason was
given. Letter: mysterious energy. Cable from
Dorothy Norman: Insufficient oxygen. You were very high. And
do you sing and dance? Not with words
but with the sounds that language had before it began?
He gave an example. Sometimes a word's included.

Chalices. Each of us having spinal trouble. We slept and sat on
boards. And laughter (next year we'll be in
wheelchairs). I was surprised when he told me that
he was considering letting any and all of the hippies
he'd met have land on the shore of the lake. "No one will throw
you out." SI SI jiSISIjiSISIjiSISIjiSIji
jiSISIjiSIjiSISIjiSISISISIjiSIjiSISIjiSIjiSISIji
Which is the most offensive aspect of technology?
Its smell? The look of it? Its effect on food and water? Its
sounds? Or is it that anything anyone does with his hands seems
useless in the face of technology's lavalike
continuation? When the door was finally opened
there were drawings and paintings everywhere: on all the
furniture, including the bed; on the walls and the
ceiling. We had to walk carefully so as not to step
on them. The table had not been cleared. There
were scraps of food on the plates. Stem removed. An eyelike shape
remained. Bird waiting to be born. Deep in the Ocean. If you descend
to the uttermost depths, there you will find the gem of Love.
Go seek, O mind, go seek Vrindavan in your heart, where with His loving
devotees Sri Krishna sports eternally. Was Graves with us when the
earthquake took place? All the people who had
never met, even though they lived next
door to one another, met then and there in the vacant lot.
Conversed with one another.

Now there is no escape. Tanzania, Uganda, Egypt, the islands of
Greece and Greece itself, Italy, France, New York. The King of Sikkim,
Graves told me, has rare clarity of mind. He is a
devout Buddhist scholar. His
meditations are those of a guru. His
conversation's not chitchat. It conveys the best of
his mind. The more closely attention is given, the
more difficult it becomes to
fix something by name, or by relation to other
things. It begins to move on into
another being. Floor covered with sand. Large tree
trunk that'd drifted up on the beach off center in the room, ice
cream chairs in circle facing it. Cawing of the crows,
patiently trained, made
conversation impossible. They stayed where he'd placed
them: on top of the driftwood. Communion. The blood. He wasn't a
student. Why wouldn't they let him in the
school? giTATAgiTATAgiTAgiTATAgiTAgigiTA I suggested sitting
down. He said that way he'd have to have other brushes.

Unwashed dishes temporarily put out of sight in
drawer lined with silver paper.

He filled a baby carriage with rocks and,
with strings, made a trailer for it of
toothbrushes. He pushed it downtown to the Olympic
Hotel, through its halls to the
main dining room. After placing a rock at
each chair but one, he then sat down and
ordered dinner. Seattle. They enjoyed an
immediate friendship. They talked about the mystery of death, the
nature of the next
dimension. Before long a certain
lightheartedness entered into their conversation. He could not tell
whether he was awake or dreaming or whether what
was happening was happening. Titan missile had been getting bad
publicity (two launchings had gone sideways into the
ocean); Pentagon feared greater publicity would
affect NASA funding. NANG taNANGNANGtaNANGNANGta
NANGta Second, the soot and dirt are removed from the rooms. In
this totality the conscious mind is contained like a
smaller circle within a larger one.

Petroleum fire. USA: red-orange.
Canada: forest green. Ashes. Out of Gulf rose huge
Negresses moving like gorillas.

Has he told you anything about the actual
process of painting or drawing? "Work periods are often very
long, going through the night into the next day or days." He continues
until the spirit leaves. Portico over
the terrace was supported on one side by the house, on the other by
handsomely rough-sawed hexagonal tree trunks
used as columns. There was a pool with lotus. The school's registrar
was coming to lunch. Just
when she was to arrive, there was a knock at
the door. Xenia opened it.
Morris, stark naked, was standing in the hall.
Zosimos: "And everything will be moistened and
become desiccated again, and
everything puts forth blossoms and everything withers again in the bowl
of the altar . . . For nature applied to nature
transforms nature . . . all things hang together."
ra

They used rafts, piling on them duckweed and water strawberry that
had grown too thickly, moving slowly from bay to bay.
As they continued their work, more and more the sky and
the forest were reflected in the surface of the water.
Repeating what he had told was taken as an insult. He
threw the cup of boiling tea. I was obliged
to leave the room. The Duke and the Duchess.
Photographer looks at you but snaps
himself. Fisherman's transformed by what he
catches. Three tables? Or is one
sufficient? Providing it's large? The colors to the
left, the brushes to the right, the paper
directly in front. And the water? Surely it's here and there,
right and left, ready no matter what. Minnow
has put the egg back together again.
Amazonlike demonesses and nearly naked. They were replaced by
thousands of stick figures:
ants moving through the ashes.
RA maRARAmaRARAmaRAmaRARA
maRAmamaRARAmaRAmaRARAmaRARARAmaRAmaRARAmaRARARAmaRARAmaRA
Surface of the water responds to the
currents of the air and to birds, their floating, their takeoffs,
their touchdowns. My work is done: now the telephone
comes off the hook. Time for a nap before supper.

The footman rolled out the red carpet up the
museum steps. liKAKAliYUYUgaKAliYUYUgaKAligaKA
KAliYUgaKAKAliKAYUKA We fly
to place where no airplane is.
Secluded house throbs with
utilities.

The wise man gladly leaves fame to others. He does
not seek to have credited to himself
things that stand accomplished, but hopes
to release active forces. He was offstage left, invisible to the
audience. After hearing his
wail, people were mystified.
They asked: How was that sound
produced? (Not who had sung it, but what strange instrument was it
that had been used?) Both sides of the windows
are washed. Windex spray and paper
toweling instead of soapy water and cloth. Variation is
introduced: some outside,
then some inside. How many
windows are there? One hundred and two.
Are you sure? Yes, I am sure. In the next box the
Princess Chichibu was sitting (Hirohito's sister).

A student needed money for trip with girl friend to Mexico.
Morris gave it; then asked the young man for help on four
weekends around the house.
Student agreed to come at 9:00. Arrived instead
at 3:00. Left at 5:00. "Nobody here wants
to work." As we went upstairs, I paused to admire
the charcoal walls, their sheen and texture. He agreed they were
beautiful. He said there had been a fire.
Except in his bedroom, all the walls upstairs
were black. For that reason he had the
house rent-free. Hong Kong. Day after receiving vision he heard
of the assassination of Martin Luther King.
Did both events happen at the same
time? A shallow window next to the bathroom ceiling
goes the lengths of two walls. It looks to the forest beyond
the garden and lawn. On its ledge are many more or less translucent
containers, empty and having different
colors. Floodlights. Guest list.
They reached the museum before the Governor did. I
stayed in the flower market. He went to look for
a shopping bag. I ate the
jacima with lime juice and chili pepper. The bag he had had to buy was
plastic. There weren't any others. kaLANLANkaLANLAN
kaLANkaLANLANkakaLANkaLANLANkaLANLAN
LANkaLANkaLANLANkaLANkaLANLANkaLANLANkaLANLANkaLAN
kaLANLANka

RA RA naRARAvaRARAvaVAnaRARAvaVAnana The world is of
the nature of magic. The magician is real but his
magic is unreal. He left Ireland, finished the
eight-foot wall around the house at Woodway Park, sold the house
and returned to Ireland. Nouveau riche: Letting
this wood rat in, you've devalued our estate
by thousands. Wife, however, invited Graves to dinner.
Tycoon's talk turned
toward view: artists are loafers. Graves countered: Look! All
you have and use (all of it!) was touched first by an
artist. Qualities of life he regards most highly: that
it flow, continuity; that there be concentration, no
interruptions; privacy, all
the way to secrecy; the mysteries of consciousness (he finds the ego
tedious), life as karma and maya. Helped by
a friend who stood watch, he borrowed the fowl
from the zoo. When we opened
the door, fowl flapped its way in.
Xenia was terrified. Algeria,
Tunisia, Kenya. I told him
what Fuller had told me. "No reason for
you to drink: you're already drunk." He
laughed in agreement.

Is it Brahman's breathing that produces
civilization's changes? Kaliyuga. Exhalation. Making
matters worse. When will
Brahman inhale?

This is His sport. You must have
observed that all
the trees in a garden are not of the same
kind. His brother Wallace, far away, dreamt Morris
needed help. Up at dawn, took boat, bus, hitchhiked. Arrived at
dusk. Ten minutes before,
great stone had slipped.
Morris's leg was pinned underneath it. Morris
couldn't move. It wasn't that way at all. The
house has never been cold and damp. He
exaggerates. He gets carried away. I
wouldn't even dream of picking up an axe and smashing a stove to
pieces. Nor would I throw myself on the
floor. Each stayed in a lonely place until he
learned an animal's song and dance.
La Conner singing re-enacted the
learning. It was a teaching.
When others learned the song, the singer began to dance.
On a shelf on one wall: pink satin slipper,
blade of wheat, and perhaps some other objects I don't
recall. On the opposite wall: a painting
duplicating the arrangement. I touched both
arrangements in order to know which one was not
three-dimensional. jaKAKAliKAKAliPUjaKAKAliPUjaliKA
KAliPUjaKAKAliKAPUKAliPUjaKAKAliPUjaKAKAliKA
KAliKAKAliPUjaKAKAliPUjaliKAli Taipei,
Hong Kong, Japan, Bali, Singapore,
Ceylon, India again (two months), again Nepal (two
weeks), ten days as guest
of the King and Queen of
Sikkim. After dinner one
evening the King granted
his request. He spoke about the *essential* yeti.

Lost in the forest, don't move around; stay in one place. That way
you will be at the center, and
the center will act as a magnet, a magnet for
those who are searching. The proverb, he said, was an ancient
Chinese proverb. Alan Watts hadn't
ever heard of it. The chaise longue upholstered
with beige linen was in the bathroom.
Lying on it wrapped in terry cloth taken from the heated towel rack, you
could look out the window to the mountain and harbor.
The carpeting, wall to wall, was grey. Nature
creates all beings without erring: this is its straightness. It is
calm and still: this its
foursquareness. It tolerates
all creatures equally: this its greatness.
Man achieves the height of wisdom when all that he
does is as self-evident as what nature
does.

BRAH BRAH maBRAHBRAHmaBRAHBRAHmaBRAHmaBRAHBRAHmaBRAHmama
BRAHBRAHmaBRAHmaBRAHBRAHmaBRAHBRAHBRAHmaBRAHmaBRAHBRAH
maBRAHmaBRAHBRAHmaBRAHBRAH And the way in
leads to the way out. Ezekiel 47:1: " . . . he
brought me again unto the door of the
house; and, behold, waters issued out
from under the threshold of the house eastward and the waters came
down from under the right side of
the house . . . " Kneeling beside the stream, she lowered her head
to drink. Had she used her hand or hands as a cup, she wouldn't
have been frightened by the snake that
appeared in the water to meet her. Wheel.
Pottery. M.C.'s poem: Hands Birds
(page's space between). Suzuki:
Hands Dirt.

maBRAHBRAHmaBRAHBRAHmaSAKtiBRAHBRAHmaSAK Twice we have
visited Fern Canyon. Earth above, earth below (K'un
K'un): nature in contrast to spirit, earth in contrast to
heaven, space as against time. Devotion. No
combat: completion. The coexistence
of the spiritual world and the world of the senses. We
listened to the traffic of the birds. A
highway. When the Baroness Mitsuko Araki was asked whom she
wanted to meet, she said, "I only want to meet
artists." He was so miserably treated he disembarked
at Cherbourg, and spent five weeks in Paris. When he
finally arrived at the castle in Chichester,
nothing but obstacles were placed in his path. The
dinner was the last straw.

As we were leaving the airport Morris
said: First thing's to take a row on the lake. I said, "What
for? Mushrooms don't grow on lakes." Years later, Ted's
voice came over the water: "Mushrooms!"
Paddling out we filled the canoe with *Pleuroti*.

We were in the flower
market (Cuernavaca). We had gone up and
down the aisles where the fruits and vegetables
are. He was carrying several that he had
bought and planned to paint. His eye
was caught by a large clay pot with a plant in
it.

"I'm the happiest person I know." (S. W.)

She does this
makes yoU
fEel

that as far as she's concerned What
you'rE up to
Is the most important thing
in the worLd

and She
withoUt
gEtting

in the Way.
shE spends
her tIme
cheerfuLly

Solving problems
Until
thEy all disappear.

a great Woman:
shE
brIghtens society
by making performing artists usefuL members of it.

When Charles Aitel, representing a group of Norman O. Brown's former students, sent me a form letter in 1977 asking me to contribute to a cento in Brown's honor, I was delighted. The moment I had the chance I got to work with pleasure. This text includes references to other friends. The automobile accident happened to Teeny Duchamp. She has had to learn to walk all over again. It was with Edith Speziali that *Pluteus cervinus* was found in Scarsdale. Richard Martin Jarrell (Tom Jarrell, a two-time draft card burner) gave me, by example, the courage to learn to make bread, and Shizuko Yamamoto changed my diet.

Sixty-One Mesostics Re and Not Re Norman O. Brown

there is no difference Between
this paRking
zOne and any other. the entire city
is a toWaway
zoNe.

which would you rather Be,
an aRtist
Or
a Work of art?
that came up at the discussioN.

discussiOn
as a form of art.

let Others have theirs
(we have ours): pun.

breakfast: the mOrning
newspaper.

 first oBjective:
 scaRsdale.
 mushrOoms
 groW
 oN

 heathcOte
 near palmer.

 find sOmething
 to think.

 yOu
 were carried away.

 we doN't
 knOw
 ouR
 dreaMs
 Asleep:
 awake we kNow them.

 Behind
 the medical centeR
 On a pile of chips
 pluteus cervinus (dry) Was
 fouNd in quantity.

 nO place to go
is everywhere.

 it was Never
 pOssible
 foR all of us
 to hunt Mushrooms together: even when you'n'i first met
stephen wAs already
 liviNg away from home.

 theN,
 thOugh
 i didn't know wheRe was there
 i drove straight towards theM.
 it wAs as though
 we'd had aN appointment.

 it has Become
 a pleasuRe
 tO go to japan
by staying at home in neW york
 makiNg nuka pickles.

 nO
 parking.

 nO
 aspirin.

 tiBetan
 baRley bread
 with rOasted
 sunfloWer seeds
 ("the oNly

 bread yOu need to know how to make, the greatest"):
tassajara bread book.

what does it meaN when we say
 sOmeone's
a complicated peRson?
 soMeone whose reply's
 unpredictAble
 horizoNtally and vertically?

 what happened (autOmobile accident)?
 you tried to climb a tree.

tO
walk. starting all over again.

Beth
will dRive.
i will gO on
With
our coNversation.

i Begin
ciRca
twenty-fOur hours ahead of time:
that Way
the hard crust is thiN and crunchy.

cOnversation
is the staff of life.

it was Because
of Repeated audible failures
tO begin and a visible uncertainty of balance
that you made me feel i Was
iN a theater.

yOu held on to the lectern
as though for dear life.

Sixty-One Mesostics Re and Not Re Norman O. Brown : 127

the oNly way
tO
conveRse with you
is to be in the saMe room
or in the sAme car
or oN the same path:

the telephOne
doesn't work.

your stutteriNg's a basket.
it allOws you
to gatheR together
More
ideAs
thaN

a sentence Ordinarily would be able
to hold.

agaiN it happens:
nO
diffeRence between relevance
and irrelevance: More'n'more
All
thiNgs go together.

the day was saved By
dReaming:
Once
i Was awake
there was Nothing

But
poetRy.
cOver it
With a damp cloth
aNd leave it in an oven with the pilot light on.

at the Beginning
it sticks to eveRything and falls apart
but as yOu
Work with it
it takes shape aNd

Becomes elastic. we've always meant
to be healthy but the last time we thRee were
in a health fOod store together
We were tourists
lookiNg

for sNacks.
my shOpping list today:
bRown rice,
sesaMe seeds,
tsAmpa,
peaNuts.

your seNse
Of
theateR
caMe through even on the recording.
but still i would rAther
have actually beeN

iN the hall
sO i could have seen you
while you weRe speaking.
Mix the flours with the oils,
your pAlms together, right-left,
as though you are marchiNg.

this is the first summer i've decided tO stay
in the city.

Sixty-One Mesostics Re and Not Re Norman O. Brown : 129

there are never any proBlems about how to spend
ouR time.
each Of us
has his Work
which caN always

Be left unfinished in the case
of chess oR
mushrOoms or
Whatever.
there's Never so much time

But that
i look foRward
tO the next time
We meet.
wheN will that be?

yOu and beth live
over three thousand miles away.

no one knows how to converse But you. is it because you do
so much Reading?
dO you talk to yourself
While
you're writiNg?

aNd
nOw
i do exeRcises. they began
because of Muscle
spAsms
iN venezuela.

i cOuldn't walk: i was crawling
on the floor.

a year later the pain Behind my left eye began.
the doctoRs
cOuldn't explain it.
i Was
takiNg pills

One after another
just in order to sleep.

the fuN we have talking
is to nO avail.
we neveR
coMe
to the end of A subject.
somethiNg always remains

to Be said.
you must make otheR
peOple
feel the same Way: that thought goes
oN and on —

mOuntain,
tranquility at the base of the mountain.

— that nOthing
ever comes to an end.

you've Never
tOld me.
aRe you still their father
and beth their Mother?
or Are you just
their frieNds?

to Become
fRee:
nOt
to knoW
whether we kNow or not.

Sixty-One Mesostics Re and Not Re Norman O. Brown : 131

visioN: family.
nO
fatheR,
no Mother.
just All of us.
us childreN. together.

the wind is blOwing
backwards.

we are in danger Of becoming
undernietzscied.

i never met your mother, But
i Remember
yOu told me
she Was
a clairvoyaNt or a theosophist,

i doN't remember which. she grew up
in ireland and yOu
weRe born in vera cruz
(i think that's what you told Me):
your fAther was employed there
as as aN engineer. (isn't that the way it was?)

where was he bOrn? tell me (you've told me, i'm sure, but please,
please tell me over'n'over, please tell me again).

In 1939 I bought a copy of *Finnegans Wake* in a department store in Seattle, Washington. I had read the parts of *Work in Progress* as they appeared in *transition*. I used outloud to entertain friends with *The Ondt and the Gracehoper*. But even though I owned a copy, no matter where I lived, the *Wake* simply sat on a table or shelf unread. I was "too busy" writing music to read it.

In 1942 Janet Fairbanks asked me for a song. I browsed in the *Wake* looking for a lyrical passage. The one I chose begins page 556. I changed the paragraph so that it became two and read as follows:

"Night by silentsailing night, Isobel, wildwood's eyes and primarose hair, quietly, all the woods so wild, in mauves of moss and daphnedews, how all so still she lay, neath of

Writing for the Second Time through Finnegans Wake

the whitethorn, child of tree, like some losthappy leaf, like blowing flower stilled, as fain would she anon, for soon again 'twill be, win me, woo me, wed me, ah weary me! deeply, now evencalm lay sleeping;

"Night, Isobel, sister Isobel, Saintette Isobelle, Madame Isa Veuve La Belle."

The title I chose was one of Joyce's descriptions of her, *The Wonderful Widow of Eighteen Springs.*

I remember looking in later years several times for other lyrical passages in the *Wake*. But I never settled on one as the text for another song.

In the middle 'sixties Marshall McLuhan suggested that I make a musical work based on the *Wake's* Ten Thunderclaps. He said that the Thunderclaps were, in fact, a history of technology. This led me to think of Jasper Johns' *Painted Bronze* (the cans of ale) and to imagine a concert for string orchestra and voices, with the addition towards the end of wind instruments. The orchestra would play notes traced from star maps (*Atlas Borealis*) but due to contact microphones and suitable circuitry the tones would sound like rain falling, at first, say, on water, then on earth, then wood, clay, metal, cement, etc., finally not falling, just being in the air, our present circumstance. The chorus meanwhile would sing the Thunderclaps, which would then be electronically transformed to fill up the sound envelopes of an actual thunderstorm. I had planned to do this with Lejaren Hiller at the University of Illinois 1968–9, but *HPSCHD* took two years rather than one to make and produce.

Due to N. O. Brown's remark that syntax is the arrangement of the army, and Thoreau's that when he heard a sentence he heard feet marching, I became devoted to nonsyntactical "demilitarized" language. I spent well over a year writing *Empty Words*, a transition from a language without sentences (having only phrases, words, syllables, and letters) to a "language" having only letters and silence (music). This led me to want to learn something about the ancient Chinese language and to read *Finnegans Wake*. But when in this spirit I picked up the book, Joyce seemed to me to have kept the old structures ("sintalks") in which he put the new words he had made.

It was when I was in this frame of mind that Elliott Anderson, editor of *TriQuarterly*, wrote asking me to write something (anything, text or music) for an issue of the magazine to be devoted to the *Wake* (In the wake of the *Wake*). I said I was too busy. I was. I was writing *Renga* and had not yet started *Apartment House 1776* the performance date of which had al-

ready been set. Anderson replied that his deadline could be changed. I refused again and again. He persisted.

Anderson was not the first person to bother me by asking me to do something when I was busy doing something else. We continually bother one another with birthdays, deadlines, celebrations, blurbs, fund raising, requests for information, interviews, letters of introduction, letters of recommendation. To turn irritation into pleasure I've made the practice, for more than ten years now, of writing mesostics (not acrostics: row down the middle, not down the edge). What makes a mesostic as far as I'm concerned is that the first letter of a word or name is on the first line and following it on the first line the second letter of the word or name is *not* to be found. (The second letter is on the second line.) When, for instance, we were in a bus in Northern Michigan on our way to hunt morels (Interlochen music students were asking me what a mesostic was), I wrote



"Music . . .



(the M without an O after it)



"Music
cOnducted . . .



(the O without an R) (the word "performed" would not have worked)



"Music
cOnducted
in spRing . . .



(the R without an E)



". . . by trEes: . . .



(the E without an L)



". . . dutch eLm disease."



To bring my correspondence with Elliott Anderson to a temporary halt, I opened *Finnegans Wake* at random (page 356). I began looking for a J without an A. And then for the next A without an M. Etcetera. I continued finding Joyce and James to the end of the chapter. I wrote twenty-three mesostics in all.

I then started near the end of the book (I couldn't wait) for I knew how seductive the last pages of *Finnegan* are.



my lips went livid for from the Joy
of feAr
like alMost now. how? how you said
how you'd givE me
the keyS of me heart.





Just a whisk brisk sly spry spink
spank sprint Of a thing
i pitY your oldself i was used to,
a Cloud.
in pEace



Having found these, I looked for those at the beginning and, finally, as Joyce had done, I

began at the end and continued with the beginning:

<pre>
 Just
 A
 May i
 bE wrong!
for She'll be sweet for you as i was sweet when i came
 down out of me mother.

 Jhem
 Or shen [brewed by arclight]
 and rorY end
 through all Christian
 minstrElsy.
</pre>

The bracketed words are the ones I'd have omitted if it were just now I had written them. There were choices to be made, decisions as to which words were to be kept, which omitted. It was a discipline similar to that of counterpoint in music with a cantus firmus. My tendency was towards more omission rather than less.

<pre>
 Just a whisk brisk sly spry spink . . .
</pre>

became

<pre>
 Just a whisk
 Of
 pitY
 a Cloud
 in pEace and silence.
</pre>

And a further omission was suggested by Norman O. Brown, that of punctuation, a suggestion I quickly acted on. Subsequently, the omitted marks were kept, not in the mesostics but on the pages where they originally appeared, the marks disposed in the space and those other than periods given an orientation by means of *I Ching* chance operations. Where, in all this work, Joyce used italics, so have I. My marginal figures are source pages of the Viking Press edition of *Finnegan.*

Stuck in the *Wake.* I couldn't get out. I was full of curiosity about all of it. I read *A Skeleton Key.* . . . Ihab Hassan gave me his book, *Paracriticisms,* and two others: Adaline Glasheen's *a second census of finnegans wake* and Clive Hart's *Structure and Motif* I continued to read and write my way through all of *Finnegans Wake.*

Finnegans Wake has six hundred twenty-five pages. Once finished, my *Writing Through Finnegans Wake* had one hundred fifteen pages. My editor at Wesleyan University Press, J. R. de la Torre Bueno, finding it too long, suggested that I shorten it. Instead of doing that, I wrote a new series of mesostics, *Writing for the Second Time Through Finnegans Wake,* in which I did not permit the reappearance of a syllable for a given letter of the name. I distinguished between the two J's and the two E's. The syllable "just" could be used twice, once for the J of James and once for the J of Joyce, since it has neither A nor O after the J. But it

could not be used again. To keep from repeating syllables, I kept a card index of the ones I had already used. As I guessed, this restriction made a text considerably shorter, forty pages in all.

My work was only sometimes that of identifying, as Duchamp had, found objects. The text for *TriQuarterly* is *7 out of 23*. Seven mesostics were straight quotations, e.g., this one from page 383:

> he Just slumped to throne
> so sAiled the stout ship *nansy hans*.
> froM liff away.
> for nattEnlaender.
> aS who has come returns.

In such a case my work was merely to show, by giving it a five-line structure, the relation of Joyce's text to his name, a relationship that was surely in these instances not in his mind, though at many points, as Adaline Glasheen cheerfully lists, his name was in his mind, alone or in combination with another name, for example, "poorjoist" (page 113), and "joysis crisis" (page 395).

When I was composing my *Sonatas and Interludes,* which I did at the piano, friends used to want to know what familiar tunes, *God Save the King* for instance, would sound like due to the preparations between the strings. I found their curiosity offensive, and similarly from time to time in the course of this work I've had my doubts about the validity of finding in *Finnegans Wake* these mesostics on his name which James Joyce didn't put there. However I just went straight on, A after J, E after M, J after S, Y after O, E after C. I read each passage at least three times and once or twice upside down. (Hazel Dreis, who taught us English binding, used to tell us how she proofread the *Leaves of Grass,* an edition of which she bound for San Francisco's Grabhorn Press: upside down and backwards. When you don't know what you're doing, you do your work very well.) J's can thus be spotted by their dots and by their dipping below the line which i's don't do. Difficult letters to catch are the commonest ones, the vowels. And the consonants escape our notice in empty words, words the mind skips over. I am native to detailed attention, though I often make mistakes: I was born early in September. But I found myself from time to time bursting into laughter (this, not when the *Wake* was upside down). The play of sex and church and food and drink in an all time all space world turned family was not only regaling: it Joyced me (in places, that is, where Thoreau hadn't, couldn't, where, left to myself, I wouldn't've). I don't know whom to connect with Joyce ("We connect Satie with Thoreau"). Duchamp stands, I'd say, somewhere between. He is, like Joyce, alone. They *are* connected. For that and many other reasons. But that's something else to do.

I am grateful to Elliott Anderson for his persistence, and to the Trustees of the James Joyce Estate for permitting the publication of this work.



JOHN CAGE
New York City, May 1977



I

wroth with twone nathandJoe 3
A
Malt
jhEm
Shen

pftJschute
sOlid man
that the humptYhillhead of humself
is at the knoCk out
in thE park

Jiccup 4
the fAther
Most
hEaven
Skysign

Judges
Or
deuteronomY
watsCh
futurE

pentschanJeuchy
chAp
Mighty
cEment
and edificeS

the Jebel and the 5
crOpherb
flYday
and she allCasually
ansars hElpers

Jollybrool
And
6 strupithuMp
and all thE uproor
aufroof S

to fJell
his baywinds' Oboboes
7 all the livvYlong
triCky
trochEes

` whase on the Joint
whAse
foaMous
oldE
aS you

Jamey
8 ` , Our
countrY
is a ffrinCh
soracEr this is

the grand mons inJun this is
the Alps hooping to sheltershock
the three lipoleuMs this is
thEir
legahornS

Jinnies
is a cOoin her
9 phillippY
dispatCh
to irrigatE the willingdone

the Jinnies
fontAnnoy
bode belchuM
bonnEt
to buSby

10 this is the hinndoo waxing ranJymad
fOr
the hinndoo seeboY
Cry
to the willingdonE

138 : E M P T Y W O R D S

 Jist 11
 Appear
 toonigh Militopucos and toomourn
 wE
 wiSh for a muddy

 muJikal 13
 chOcolat box
 i saY
 inCabus
 usEd we

 mammon luJius
 grAnd
 historiorúM
 wrotE near
 blueSt

 Jerrybuilding 15
 tO the
 Year year and laughtears
 Confusium ?
 hold thEm

 this carl on the kopJe
 pArth a lone
 forshapen his pigMaid
 hoagshEad
 Shroonk his plodsfoot

 'tis a Jute 16
 swOp hats and excheck a few strong verbs
 Yapyazzard abast
 mutt has has at hasatenCy
 i trumplE from rath in mine mines

 Jute
 one eyegoneblAck
 cross your qualM
 havE
 Sylvan

 obJects 19
 Olives beets
 oldwolldY
 Cargon of
 prohibitivE pomefructs

20 doublends Jiried
 mAy
 Mud
 sundEr
 who oped it cloSeth

21 and Jarl)
 van hOother
 laYing
 Cold hands
 on himsElf

 and his two little Jiminies cousins of
 cAstle
 be derMot
 ! comE to the keep of
 a roSy

 Jiminy
 with sOft
 Years' walk
 to tauCh him
 his ticklEs

27 you were the doubleJoynted
 jAnitor
 the Morning
 thEy were delivered and you'll be a grandfer
 when the ritehand Seizes what the lovearm knows

 hetty Jane's a child
 she'll be cOming
 theY're
 tourCh
 to rEkindle the flame

 she'll do no Jugglywuggly
 with her wAr souvenir
 Murial
 assurE
 a Sure there

 Jubilee 31
 ` scAtterguns
 faMily symbolising puritas
 pEr
 uSuals ⟍

 Japijap
 amOng
 ⟨ sibYlline
 mulaChy 32
 kingablE khan

 practical Jokepiece 33
 cecelticocommediAnt
 his house about hiM with
 invariablE
 broadStretched

 Juke and kellikek families
 at One time
 annoYing
 C.
 Earwicker

 Jesses 34
 ripe occAsion
 our kadeM
 villaplEach vollapluck
 fikup for fleSh nelly

 guinness thaw tool in Jew me dinner · ˘ 35
 · Ouzel fin
 a nice how-do-You-do
 in poolblaCk
 timE (

 Jurgensen's
 shrApnel
 coMmunionism
 usucapturE
 the Same ‘

 tongue and commutative Justice that there is ? 36
 nOt one tittle of ·
 hYpertituitary 37
 mannleiCh
 cavErn ethics

Writing for the Second Time through Finnegans Wake : 141

39 blue ruin and creeping Jenny

 eglAndine's choicest herbage

40 Man's

 swEll

 that aimSwell

41 \ many Jiffies

 furbishing pOtlids doorbrasses scholars' applecheeks and

 linkboY's metals

 Cross

 Ebblinn's chilled hamlet

 subJects

 of king sAint

 salMon

 alivE

 with their priggiSh mouths all open

 a house of call at cuJas place

 Old sots' hole

 bY

 setting a matCh to

 stEwards peut-être

42 Joined

 hAdbeen variety

 had stiMulants

 in the shapE of gee

 and geeS

43 Juiced after taking their

 liquOr from

 highwaY and brown byway

 sCotia picta

 and hE who denays it may his hairs be rubbed

 his maJesty

 thAt onecrooned king

 aMong

 rapsods pipEd

 decentSoort

45 Jail

 chOrus

 jail of mountjoY jail him and joy he was

 siCk

 sEven dry sundays a week

 Joulting 47
 the bAcktrap
 oMnibus
 caught his dEath
 of fuSiliers

 (

 mr J. f. jones 48
 colemAn of lucan taking four parts
 in *fenn Mac call and*
 sErven
 feerieS

 Juxta- 51
 explanatiOn was put in loo of
 eYes
 lokil Calour and lucal odour
 to havE

 to sillonise his Jouejous the ghost 56
 of resignAtion
 May gloat
 Effective ,
 beam of Sunshine

 kitnabudJa
 tOwn
 or panbpanungopovengreskeY
 their Compass ¿ 57
 mElos yields the mode

 pro tried with Jedburgh justice
 Acquitted con- ,
 testiMony 58
 with bEnefit of clergy
 madthing haS done him

 Judgements
 thOse as
 daYs
 (Camps
 concurrEd

Writing for the Second Time through Finnegans Wake : 143

61 Jilke
 begAn to
 Moult
 instEnch of
 gladSome rags

62 poor Jink
 fOllowing
 roY's

63 suCh bash in patch's
 bEyond recognition

–64 came down with homp shtemp and Jumphet
 to the tiltyArd
 froM
 a'slEep
 ohny overclotheS

 reJaneyjailey
 walters Off
 whYte
 a pinCh
 idEal

 leave astrelea for the astrollaJerries
 for the love of the sAunces
 puddywhackback to paMintul and roll away
 rEel
 and call all your Smokeblushes

65 by a large Jugful
 sOmeplace
 on the slY where furphy he isn't by old grum
 Could
 canoodlE the two chivee chivoo all three

67 carcasses mattonchepps and meatJutes
 on behAlf of
 otto sands and eastMan
 wEnt and with
 unmitigated aStonissment hickicked at

68 her Jambs
 each Other
 the nautchY girly
 rapidly took to neCking
 sElling her spare favours

 for the reJoicement of foinne loidies ind
 contrAstations
 with inkerMann and so on and sononward
 flEe
 celeStials one clean turv 71

 his manJester's
 vOice
 had to fall theY 73
 slouCh
 backwords *Et cur heli*

 ziJnzijn zijnzijn
 hAsten selves
 in a finglas Mill 75
 prayEd
 on anxiouS seat kunt ye neat gift

 two Jars
 and several bOttles though 82
 Ye
 asked in the vermiCular
 - with a vEry oggly chew-chin-grin

 Joking
 chAnge
 excelcisM
 rathEr
 amuSedly replied

 J. j. and s. 83
 befOre
 first wind of gaY gay and whiskwigs
 wiCk's
 Ears pricked up

 liberties of the pacific subJect 85
 circulAting
 seMitary thrufahrts
 opEn to buggy and bike
 or quaker'S quacknostrum

Writing for the Second Time through Finnegans Wake : 145

86

 the whole padderJagmartin tripiezite
 cOpperas had fallen off him
quatz unaccountablY
 like the Chrystalisations of alum
 on Even while he was trying for to stick fire to
 ?

 christies and Jew's i
 bAllybricken
 aniMal's sty
 strEet
 Sta troia

88

 some maJar
 bOre
 erchenwYne
 Crumwall
maximus Esme

89

tongue in a pounderin Jowl
 mAthers of prenanciation
 quare hircuM
 no answEr *unde gentium fe...*
 Siar i am deed

90

 Jah and
 i shOuld
 Yes your brother
 struCk him
bank in multifarnham whEther he fell in with

 punic Judgeship
 penAl law
91
 stucckoMuck
 had bEen removed
 at the requeSt of

 the gentlemen in Jury's
 whO had been
 those Yarns yearning for that good one about
 Coddling doom as
 stEak

92

pegger's windup cumJustled
 neAtly with
 the syMphysis of
 antipathiEs
 diStinctly different

festives and highaJinks arid 94
 nOw
 a tradewinds daY and the o'moyly 95
 rossies Chaffing
 him bluchfacE and playing him pranks

 and Jonnies
 hold hArd
 i'M glad a gull
 for his pawsdEen fiunn
 Sez he lankyshied gobugga ye sez

 Jackass 96
 the rOse
 rogues lean to rhYme
there was never a marCus at all
 \ among the markiEs

 across the Juletide's 97
 geniAl corsslands of
 Mullinahob
 bEaring right upon
 tankardStown

 the Jenny
 hOux
 and Yew 98 *
 _ evereaChbird –99
 glEam

 Jest
 gregArious
 fieldMarshal
 princE
 myleS the slasher in his person

 spike of smoke's Jutstiff 100
 frOm
 porphYroid buttertower and then thirsty
 baCkwords
 morE strictly

 van diJke
 grAvitational pull
chancedrifting through our systeM
 quick spEak
 dumb huSh

Writing for the Second Time through Finnegans Wake : 147

101 ' '

 Jeer
 tOo and
 zhanYzhonies
 and murrmurr of all the maCkavicks
 shE who had given his eye for her bed and a tooth

 '

104 *Journey to*
 Ark see
 the cooMbing of
 the parlourmaids of aEgypt
 placeat veStrae

105 *he's my o'Jerusalem and i'm his*
 pO
 my juckeY
 from viCtrolia
 nuancEe to

 Jumbo
 to j.Alice
 two ways of opening the Mouth i
 not stoppEd
 water where it Should flow and i know

106 *the first book of Jealesies*
 childsize herOes
 howke cotchme eYe
 abe to sare stood iCyk
 nEuter till brahm taulked him common sex

107 a Jolting
 preArranged
108 ' Mountback against a partywall
 bElow
 uSe of quill or style

113 ' ' Jully glad
 when christmas cOmes
114 aYe to aye
 notiCing that
 linEs

Jew 116
fAr
in duMbil's fair
Ere
our coaSts

your maJesty
bOost from
allvoYous
volapuCky
gromwElled

three Jeers 117
for the grApe vine and brew
.ruM
smElt
hiS end for him and he dined

deJectedly 121
in the diapered windOw margin
basque of baYleaves all aflutter
Curious
protoparEnt's *ipsissima verba*

Jims
sAhib
pipless as threadworMs
innocEnt
exhibitioniSm.

quatrain of rubyJets 122
withOut
loYal
lobster loCks
you'rE another he hasn't

fJorgn 124
wAs
he reMains
postscrapt sEe
Spoils

looJing 125
tOrba's nicelookers of
olderlY's
noClass billiardhalls with an
had somE little laughings and some less of cheeks

126
 Jhon
 rAted
 Mic
 hE
 miSunderstrook and aim for am ollo

134
 his indian name is hapapoosiesobJibway and his number
 the plOugh took
 moves in vicous cicles Yet remews the same
 portobello equadoCta
 thErecocta percorello

136
 geulant on a fJeld duiv
 ruz the hAlo off his varlet
 put a roof on the lodge for hyMn and a coq in his pot pro homo
 thEn
 pancircenSor then hortifex magnus

138
 màde man with Juts that jerk and
 cOme whome sweetwhome
 shampaYing down
 to Clouts
 and pottlEd porter

142
 simon Jorn
 bArty
 Mor and tom
 and how war yorE
 maggieS answer they war loving they love

143
 horsa's nose and Jeff's
 gOt the signs of ham round his mouth
 violet's dYed
 what' sour lovemutCh
 but a brEf burning till shee that drawes dothe smoake

144
 like Jolio
 i hAven't fell so turkish for ages
 end of the Moon
 fool bought cabbagE head
 i Shall answer to gracious heaven

145
 the Jumps
 in her stOmewhere
 maY they fire her for a barren ewe so she says
 Cat you
 mEek my

hairmeJig 146
 lAughing
 My
 risE out
 leaSt

 Jess katty 147
 lOu
 opsY poll queeniee ruth
in for the Church
 wE've all comefeast like the groupsuppers

 are you enJoying this
 breAk 148
 i aM
 i swEar i am
do you prefer itS in these dark nets if why may ask

as none of yðu knows Javanese 152
 minOr
 take Your head out of your
 faCts
 gripEs

 cheek by Jowel 153
with his frishermAn's blague
 for an aniMal 154
 ruralE
 abaSe you baldyqueens gather behind me satraps

 kelkefoJe funcktas 160
 ' kelkefOje
 crYing to
 reCoil
 with a grEat leisure

 that is where the Juke comes in 162
 hAving
 chaMpaign
flop as a plankriEg
 the twinfreer typeS are billed to make their reupprearance

a king off duty and a Jaw
 gOod
somun in the salm butYrum et mel 163
 ut sCiat
 rEprobare malum et eligere bonum !
 !

Writing for the Second Time through Finnegans Wake : 151

recommending the silkebJorg
 mAchine for the
 econoMical
 spacE to look
 mySelf a little more closely

168 would meself and mac Jeffet
 fOur-in-hand foot him out
 aY were he my own breastbrother
 bum and dingo jaCk by churl
 though it brokE my heart to pray it

 i

169 Jem is
 jAcob.
 he was of respectable steMming
 an outlEx
 between the lineS of

170 Juicejelly legs
 mOlten mutton
171 greekenhearted Yude
 attouCh
 what happEns when

172 Johns is
 next plAce
 feel his laMbs
 fEel
 how Sheap exex his liver

173 three Jeers
 his rOtten little
 bottom sawYer till nowan
 laCk
 sEmantics

175 sachsen and Judder
 word mAde warre
 heMpal
 must tumpEl
 broken eggS will poursuive bitten apples

american Jump
 fOx
are we fairlYs represented
in dreamColohour
battlE of waterloo 176

mothelup Joss 177
trousers chAnging colour
in cheMs
 rEvolted
 Stellas

 in Junk et sampam 178
 On his
 straY whizzer
to avenge maC-
 jobbEr went stonestepping with

dr. poindeJenk 179
 Authorised bowdler and censor
v�elluM
blundEred
an aiSling vision more gorgeous than the one before

the Jigjagged page 180
his tOngue
in his belfrY
it took him a month to steal a marCh
hardsEt to mumorise more than a word a week

Jymes wishes 181
to heAr
druMcondriac
natE
really waS who

them bearded Jezabelles 192
rOb
marYlebone
while whistlewhirling your Crazy
 Elegies

all Jokes 193
go green in the gAzer
Mr
lEarn
to Say nay

black mass of Jigs and jimjams haunted by
innOcence
Yield our spiritus to the wind
pole the spaniel paCk
and thEir quarry

,

.

'

.·

iJypt
sAw *i*
lord saloMon
hEr
bullS they were ruhring surfed with spree

in a period gŏwn of changeable Jade
that wOuld robe the wood
off her nose *vuggYbarney*
hello duCky
plEase don't die

'

/

tapting a flank and tipting a Jutty
pAlling in and pietaring out
¿ when Maids
wEre in arc
or when three Stood hosting

and me to do the greasy Jub ¿
veɫOnica's wipers
theY've moist
Crampton lawn
baptistE me father for she has sinned

or Jude's hotel
from nAnnywater
to the lootin quarter you found his ikoM · '
tipsidE down
cornerboyS cammocking his guy

the peihos piped und ubanJees twanged
with Oddfellow's triple tiara
she swore on croststYx nyne wyndabouts she's be
,
quiCk and
` maguE
`

 herself tidal to Join
 in the mAscarete ɔ gig goggle
 it's too screaMing
 minnEha minnehi
 you muSt you must really make my hear it gurgle

 Jellybelly
 incense anguille brOnze 207
 describe her hustle along whY
 Can't you spitz on
 whilE it's hot

shins between them for isabel Jezebel and 210
 llewelyn mmArriage
 a nightMarching
 harE
 and gumbootS each for bully hayes and hurricane hartigan

 a Jauntingcar
 dOolin
 coYle
 a hairClip and clackdish
 for pEnceless

 Jill the spoon ⌡· 211
 for jAck the broth
 for Maggi
 frozEnmeat
 woman from luSk to livienbad for

 Jane in decline 214
 sOaking and bleaching
 the laundrY̓man
 Cuffs was
 hEir to the town

 tell me of John · 216
 or shAun !
 sheM and
 stEm
 Stone beside the rivering waters

Writing for the Second Time through Finnegans Wake : 155

II

220 opal who having Jilted glugg is
 fAscinated by
 Miss
 corriE
 griSchun scoula bring the babes

221 Jests
 jOkes
 interjection buckleY
222 musiC
 providEntially arranged by l'archet and laccorde

 dJowl
 releAsed
 shehind hiMs back
223 shE
 Shuffering all the diseasinesses of the

 melmelode Jawr
 up tighty in the frOnt down again on the loose drim and drumming
 Yoe
 with searCh a fling
 did diE near sea

224 he was an inJine ruber
 Aunts to give
 whoM
 inhEbited
 hehry antletS on him

225 ploung Jamn
 his spOkes
 mitzYmitzy though i did ate
 van diemen's Coral
 pEarl

 othersites of Jorden 228
 heAve a hevy
 tinsaMmon
 till farthEr 229
 alterS

 send Jarge
 and daunt yOu logh
 if his vineshankY's
 inform to the old sniggering publiCking
 prEss and its nation of sheepcopers

 he would Jused sit it
 All write down just as
 in hyMns
 ignorancE
 Seeing how heartsilly sorey he was ˑ— i

 was liffe worth leaving neJ 230
 thOledoth treetrene
 pumme if Yell
 while itCh ish 231
 shomE

 haveaJube
 sillAyass joshua ¢roesus
 seed of suMm
 aftEr at he had
 breaStplates

 Jerk
 a ladle brOom jig
 isle wail for Yews 232
 Cap
 twillEd a twine of flame

 arrahbeeJee ⌒ 234
 hAppy
 little girlycuMs
 adolphtEd
 Such

 glycering Juwells lydialight fans and 236
 le mOnade
 sing a song of singlemonth and You'll too and
 Chours
 so comE on ye wealthy gentrymen

<pre>
 theJ olly ,
 missAl too
 push the puMkik round
 annEliuia.
 i Since the days of roamaloose and rehmoose

238 like Juneses
 nutslOst`
 like the blue of the skY if i stoop for to spy's
 between my whiteyoumightCallimbs how
 makEs their triel eer's wax for

240 pure blood Jebusite
 drugmAllt storehuse
 sMily skibluh
 Eye
 alioS

242 so she not swop her eckcot hJem
 hOwarden's castle englandwales
243 as hundreads elskerelks' Yahrds of annams
 faCtory
 frEsh and fiuming at the mouth

245 the width of the way for Jogjoy hulker's cieclest elbownunsense
 his dithering dAthering waltzers of
 jeMpson's
 wEed
 deckS

-246 , de oud huis biJ de kerkegaard
 whOopee
 saucY ·
 Campus calls
 girls arE merchand

 Jerkoff
 eAtsoup
 yeM or yan
 whilE
 felixed iS who culpas does and harm's worth healing

253 splitten up or recompounded an isaac Jacquemin
 maurOmormo milesian how ,
254 three stout sweYnhearts
 of the orgiasts meeresChal macmuhun
 Extremes giving quotidients to our means
</pre>

bier wiJn 256

 Advokaat withouten pleaders

 Mas marrit pas poulit ras

is huEd

of each'S colour

kedocrendunandurraskewdylooshoofermoyportertootyzooysphalnabortansporthaokansakroidverJkapakkapuk 257

upplOud

 Youd 258

hear us loud graCiously

 hEar us

 Judges 263

 gAy lutharius

 Month with 264

 thrEe

 Saturnine settings

lead us seek o June 266

 thOu who fleeest

 thYself

 attaCh

with thinE efteased ensuer a question of

the law of the Jungerl 268

 eArly

 jeMmijohns

will cudgEl

browne and nolan'S divisional tables

 of Jemenfichue will sit and knit

halfwayhOist

 pYgmyhop a washable

love by seCond 269

 prudE

 Jeg suis

 thou Arr

 M. 50–50

 οὐκ"Ελαβον πόλιν

cookcook Search me

273 mangay mumbo Jumbjubes
 mutts and jeffs muchas bracelOnettes
274 death raY stop him
 entre Chats
 dundErhead

 big gleaming Jelly
 for good vAunty years
275 in any large luMps
 gEek
 got the Strong of it

 into Jinglish janglage
 dOlphins ,
276 babeteasing us out of our hoYdenname
 sate with beCchus zumbock ?
 achEvre
279) Jr
 my lifstAck
 to piMp !
 my impEnding marriage ,
 nature tellS everybody

280 *la Jambe de marche*
 suppOsed adeal
 shall plaY
 her sideCurls
 latEr
281)
 aux Jours
 des bAtailles
 blottoM
 warE
 trifid tongueS you daredevil donnelly

282 hooJahs
 kOojahs up
 his fanden's catachYsm
 Caiuscounting
 in the scalE of pin puff pive piff piff puff pive

290 *par Jure*
 you plAit nuncandtunc and
 Mams
 spottpricE
 i twaS he was

 in Juwelietry 291
 kickychOses and madornaments
 and mYrtle
 at the reCtory
 vicaragE road

 ! Jup 294
 off cArpenger strate
 with olaf as centruM
 cyclonE allow
 makefearSome's ocean you've actuary entducked one

 kapitayn killyhook and the Jukes 295
 private prOperties
 a night of thoughtsendYures and a day
 in effeCt
 yulEs gone by

 a gouvernament Job 301
 moAnday tearsday
 thuMpsday
 fEar of the law
 look at thiS twitches

 low Jure 302
 lOved to see
 the macbeths jerseYs
 knaCking spots of
 Eagles sweet

 last line from smith-Jones-orbison
 yeArs
 jirryaliMpaloop
 hup u bn gd grl lifp yEar
 fendS you all and moe

 twofold truth and the conJunctive appetites 305
 Oppositional orexes
 roYally toobally
 thou in shanty thou in sCanty shanty thou in slanty scanty shanty
 bidE in your hush bide in your hush

 Julius 306
 cAesar
 cheMistry
 disciplinE
 at the South city markets belief in giants

Writing for the Second Time through Finnegans Wake : 161

308 new yonks from Jake jack
 and little sOusoucie

 ,

 ,

 ,

310 patent number 1132 thorpetersen and synds Jomsborg selverbergen
 twintriodic singulvAlvulous
 tyMpan
 bauliaughaclEeagh
 culpable of cunduncing naul and Santry

 or one watthour bilaws below till time Jings ,
 hOst
 indtil the teller oYne of an oustman in skull of skand
 when he pullupped the turfeyCork by
 grEats of gobble out of lougk neagk

312 rotary Jewr
 plebs but plAbs
313 consistently blown to adaMs
 '
 ⌡ so hElp me boyg
 who keepS the book

315 nogeysokey first cabootle segund Jilling
 that Oerasound
 the snarstY weg for publin so was his
 him how the hitCh did do this
 my fand sulkErs

317 he apullaJibed
 dAn so
 Mansk
 likE a dun darting dullemitter with
 Stuck in plostures

318 Jilt the spin ,
 and jOlt
 ' a buoY
 lowCasts
 atEn of amilikan

 stuff interJoked
 boAth
 scaMptail
 irE wackering from the eyewinker
 maSttop and aye far he fared 320

with winkles whelks and cocklesent Jelks 321
 lit by night in the phOenix music
 contrescene he cupped his Years
 to Catch
 mE's to you

 torstaJ 325
 tAnssia
 lavantaj ja sunnuntaj christianisMus kirjallisuus kirjallisuus christianismus
 this pEllover
 finniSch

 Jest 331
 crOwn
 the ketYl and 332
 heC
 lovE alpy

 and the Juinnesses is 333
 rApin his hind
 the Missus
 braggEd abouve that
 her agony Stays outsize her

 it pickles up the punchey and the Jude 334
 yOu'll
 Yule to the day and it's hey tallaght hoe
 Cup
 it tEllyhows its story to 335

 Jukersmen 337
 sure to pAltipsypote
 your fingathuMbs
 hEahear
 Solowly

 aJaculate all lea light 338
 rassamble the glOwrings
 of bruYant
 Ching
 lEw mang

Writing for the Second Time through Finnegans Wake : 163

339 come alleyou Jupes of wymmingtown
grAze the calves of
heavenspawn consoMation
rEnt outraged
erminia'S

340 dJublian alps
and the hOofd ribeiro
nYe
reguleCt
wifE in the rut of

his muJiksy's
zAravence
341 act which seeMs
to sharpnEl
innermalS menody

342 gross Jumpiter whud was thud
hOld hard
major hermYn
reproduCing
form of famous sirEs on the scene of the formers triumphs

343 poJr
schtschuptAr
all the qwehrMin
of thosE
antiantS their grandoper that soun of a gunnong

344 i confesses withould prideJealice
when i lOoked
345 at Yarn's length
by wile of stoCcan his hand and of
gEtting umptyums gatherumed off

348 a great mark for Jinking
brocAde for
a burM
whEm
it bameS fire

351 blue streak Jisty and pithy
as hOmard
(kaYenne was
Choplain
bluEd

his bigotes bristling as Jittinju triggity shittery pet 352
 he shouts his thump and feeh fAuh foul finngures up
the frustate fourstar russkakruscaM dom allaf
 of sin prakticE 353
 failing to furrow theogonieS of the dommed

loud lauds to his luckhump and beJetties 358
 jOnahs and
 tombuYs disassembling and taking him apart !
 the slammoCks
with discrimination for his maypolE and

 what we warn to hear Jeff is the woods of chirpsies cries 359
 sock him up the oldcAnt rogue group a you have jest
 a haM
 bEamed
 liStening through

 grootvatter lodewiJk 361
 bOldmans
 You're
the jangtherapper of all joColarinas
 and thEy were as were they

 rosing he Jumps 363
 leAps rizing
 he's their Mark
 cErtainty owe
 he Sprit in his phiz

 e'en tho' Jambuwel's defecalties is 366
sippahsedly imprOctor
marse makes a good daYle to be shattat
 jaCq jacob's
 griEf

 k.c. Jowls 368
they sure Are wise
 Mr g.b. 369
hilly gapE
mr w.k. ferriS-fender fert fort woovil doon

 Jameseslane 373
begetting a wife which begame his niece by pOuring
 her Youngthings into skintighs
 it Crops out
 in your flEsh 374

Writing for the Second Time through Finnegans Wake : 165

375 you on her hosy Jigses
thAt'll be
fuMmuccumul
with a granEen aveiled
playing down the Slavey touch

376 Jik
yOu're getting hoovier a twelve stone hoovier
and the greY
Club too with
wEre for the massus for to feed

383 and they kemin in so hattaJocky only
384 quArtebuck askull for
old Matt
grEgory
and then beSides old matt there was

386 Jules
with the hOughers
Yaman and all the
-387 priesthunters from the Curragh
and confusionariEs and the authorities

and his crimson harness and his leathern Jib
his cheApshein hairshirt
that reMinds
mE
about the manauSteriums of the poor

then there was the official landing of lady Jales casemate in the year
the flOod 1132 s.o.s.
and then poor merkin cornYngwham
the offiCial out of
pEnsion when

394 Jool
the rAncers
egotuM
dEprofundity
of multimatHematical immaterialitieS

tootwoly torrific the mummurrlubeJubes 396

 , cOunting motherpeributts up one up four ,
 in lethargY's love at the end of it all 397
 Caxons
 wEt air register

III

)
 '
 Jistr to gwen his gwistel 406
 prAties sweet and irish too
 and Mock
 gurglE
 to whiStle his way through for the swallying

 burud and dulse and typureely Jam all free of charge aman and
 lOaves are i
 quaY (
 lynCh
 hE's deeply draiming houseanna

 take this John's 408
 lAne in your toastingfourch shaunti
 and shaunti again and twelve coolinder Moons i am
 studiEd —
 piScisvendolor you're grace futs dronk

 tackling bienie faith as well and Jucking 417
 dOrsan
 in the mYre
 aCtually
 and prEsumptuably sinctifying chronic's despair

 31 Jun. 13 421
 12 p.d. rAzed
 cuMm
 camE
 Stop

422
 he can purge his contempt and deJeunerate
 a skillytOn be thinking himself to death
 if he waits till i buY him a mosselman's present
 ho's nos halfCousin
 of minE pigdish nor wants

423
 went into the society of Jewses
 with bro cAhlls and
424
 teMp
 whEn he foiled
 the *ikiSh*

430
 girlsfuss over him pellmale their *Jeune premier*
 mussing his frizzy hAir
 siMply savouring
 wild thymE
 and parSley

 Jaun asking kindlily
 are bernadetta's cOlumbillas
431
 coY
 a bittoCk
 a sidEeye

 from sampson's tyke to Jones's *i*
 sprAt
 jaun after those few preliMbs
 iknowEd
 her waveS of splabashing and she showed him proof

435
 always Jaeger
 mOedl's with their
 danuboYes
 stiCk wicks
 ¿ whEn you hear the prompter's voice

441
 the race is to the rashest of the romping Jomping rushes of
 hAul seton's
 ad libidinuM
 if you'vE
 parentS and things to look after

divulge sJuddenly
 . jOuted out hardworking jaun
 braYing aloud like brahaam's
 kinantiCs
 in that buEl of gruel he gobed at bedgo

what do you mean by Jno 447
 jAs pagan
 traM
) wEaring the midlimb
 veStee

 Jushed astunshed 448
durn weel tOpcoated with
 tristYs blinking 449
 and jaCobus
 intErcissous

as a philopotamus and crekking Jugs
 grenoulls leAving tealeaves for the trout
 westasleep aMuckst
to watch how carEfully
 nocturnal gooSemother would lay her new golden sheegg -450

 bemolly and Jiesis
 i spOrt a
 brYony o'bryony
what sensitive Coin
 possEssed

neck and necklike derby and June to our snug 454
 retribution's rewArd the scorchhouse shunt us
saffron buns or sovran bonhaMs 455
 whichEver you'r avider
 allover irelandS

and a penny in the plate for the Jemes 456
 O.k oh
 Yon
 Coat of
 vairy furry bEst i'll try and pullll it awn mee

 the Jooks
the kelly-cooks hAve
 Milking
 marshalsEa
i firSt offenders but i know what i'll do

458

i will tie a knot in my stringameJip
it will be wOrth
simplY and solely
Comb and mirror *i*
owEs and artless awes

465

hatch yourself well enJombyourselves thurily
would you wAit biss she buds till you
Mails
togEther ,
like the corkS again brothers hungry and angry

469

Jerne
abOard for kew
solong lood erYnnana ware thee wail
now's nunC
or nimmEr

 i

470

eh Jourd'weh oh jourd'woe
to-mAronite's
oasis cedarous esaltershoMing
lEafboughnoon
oiSis

half a glance of irish frisky a Juan jaimesan
hastaluegO
sososopkY
peoCchia
pEucchia ho mi hoping ha me happinice

471

borne of bJoerne
lA garde
coos hogdaM
farvEl
Speed

473

spatched fun Juhn
that dandyfOrth from the night we are and feel and
phaYnix
Cock shall crow
wEst shall shake the east awake walk

oh Jeyses fluid 480
 sAys the poisoned well
 did you dreaM you
ating your own tripE
 acuShla that you tied yourself up

scents and gouspils the animal Jangs again
 hOwl me wiseacre's hat till
 Yu hald 481
 Chris
 drEam

 your stavrotides Jong of 482
 mAho
 and that o'Mularlchonry
 no usE
 donkeySchott

 every other woman has a Jape in her 486
 fellOw
 o seY but swift and
 bellax aCting
 likE a bellax

 when a crispin sokolist besoops Juts 491
 or clApperclaws
 Mum
 a drary lanE
 juSt hadded twinned little curls

i am writing in mepetition to kavanagh dJanaral when he 492
 as badazmy emOtional volvular
 with vallad of erill pearceY o 493
in my nil ensemble in his lazyChair
 up my hEmifaces in all my mayarannies

 alas for livings' pledJures 496
 lordy dAw and lady don
boycotted and girlcutted in debt and dooM
 on hill and havEn
 even by the Show-the-flag flotilla

 watersheads and to change that subJunct
 Once in a while
 identifY yourself with the him in you
 fluCtuous
 i nEck merchamtur

Writing for the Second Time through Finnegans Wake : 171

503 all effects in their Joints
 cAused ways
 toMbs
 dEep and heavy
 and what Sigeth woodin warneung thereof

511 the other men Jazzlike
 brOllies and sesuos was gickling his missus
 beYawnd
 tweendeCks
 dEeply painfully

 Junk
 the jungulAr
512 life out of the liffey crestofer caraMbas such is zodisfaction you
 kishEd he conquered
 muSked bell of this masked ball

514 making meJical
 shOw in sum some
 claY
 Cast
 through the schappstEckers of hoy's house

524 mr coppinger hereckons himself disJunctively
 with his windwArrd eye
 a cunifarM school of
 nazE from twelve and them
 mayridinghim by the Silent hour butting charging bracing

531 me shims and here's me hams and this is me Juppettes gause be the meter
 he never cOtched finer
 by sYlph and salamander and
 primapatrioCk of
 trancEnania

532 Jousters of the king
 eirenArch's custos
 in pontofacts Massimust
 throughout the world whErever
 good allengliSches angleslachsen is spoken

533 ! from an early peepee period while still to hedJe-
 skOol intended for broadchurch i
 have the phoneY habit
 saywhen holmstoCk
 unstEaden

 a bloweyed laneJoymt ! 534
 fAllse roude axehand he is
 thoM's
 snakEeye
 Strangler of ,
 hanging tower steck a Javelin
 thrOugh his advowtried heart)
 chrY as urs now so yous then 535
 first City's
 lEasekuays

 i cast my tenspan Joys on her 547
 Arsched overtupped
what screech of shippings what low of daMpfbulls −548
 from livland hoks zivios fromNEttland
 Skall vives with impress of asias and

 knaggs of Jets
 and silvered waterrOses
 the peak of pim's and slYne's -.
 a sChool
 of shElls of moyles marine -.

 and piebald shJelties 554
 skewbAld ,
 doMino

 -

)

 Jot 563
 sobrAt
 steelwhite and blackMail i ha'scint
 for my swEet
 -. an anemone'S letter with a gold of my bridest hair betied

 kerryJevin
 a secOnd position 564
 of sYlvious beltings ,
 are to be Caught /
 a scarlEt pimparnell

565
 gaiJ beutel
 of stAub to feel ;
 the tiMid
 vortigErn ah
 Stemming what boyazhness

568
 me amble dooty to your grace's maJers
 we but miss that hOrse elder
 alfi bYrni
 eaCla
 trEacla youghta kaptor lomdom noo
 i
571
 hedJes of
 ʻ mAiden
 ferM
 hEre in another place ʻ
 chapelofeaSes

578
 and her steptoJazyma's culunder buzztle
 selling sunlit sOpes to washtout winches and
 stepneY's
579
 eskipping the Clockback, crystal
 swEeheartedly

583
 lickering Jessup
 bAtter
 she druv behind her stuMps for a
 wink through his tunnilclEfft ʻ
 bagSlops

590
 Jeebies ugh
 jawbOose puddigood
 Yond would be
 worked out to an inCh
 his corE

 ?

 ,

 ⁄

 . .

 ⁄

IV

by Joge 594
if you've tippertAps in your head
you're silenced at henge ceolleges exMooth ostbys for ost boys -595
Each and one
death baneS and the quick quoke

he conJured himself
thetheatrOn 596
gygantogYres with freeflawforms
as of young a palatin whiteloCk
lackEd

Just 597
to rolywholyover svApnasvap of all the stranger things that
toMb
dykE and hollow
untiretieS of livesliving

the moskiosk dJinpalast
the bathOuse and the bazaar
has his staY
and all-a-dreams perhapsing under luCksloop at last
all dozE why such me

the ropper Jerks 611
jAke
vaMpas
fElla
iSlish

Jerk 615
wObblish the man what
gave me the keYs to dreamland sneakers in the grass
tiCk off
that cafflEr's head

Writing for the Second Time through Finnegans Wake : 175

616
 by Jings
 with the greAtest
 hairy of chest haMps and
 affEctionate company
 real devoteS

620
 hugly Judsys what
 chOose is left to
 Yearns
621
 nor you your ruCksunck
 hikE

622
 round the lodge of fJorn
 gAlla
 taMming
 unclE
 tim'S caubeen

626
 as on the night of the apophanypes Jumpst
 shOotst throbbst into me mouth like
 us two onlY i was but teen
 a pining Child round
 sluppEry table

 i'm sure he squirted Juice in his eyes
 to mAke
 theM flash
 for flightEning me
 Still and all he was awful fond to me

627
 Just a whisk
 Of
 pitY
 a Cloud
 in pEace and silence

This text is a revision of an earlier one finished in 1974 which was given as a lecture at the YMHA in New York City and printed in *Numus West*, No. 5–74.

The Future of Music

For many years I've noticed that music—as an activity separated from the rest of life—doesn't enter my mind. Strictly musical questions are no longer serious questions.

It wasn't always that way. When I was setting out to devote my life to music, there still were battles to win within the field of music. People distinguished between musical sounds and noises. I followed Varèse and fought for noises. Other musicians also did. In the early thirties the only piece for percussion alone was Varèse's *Ionisation*. By 1942 there were over one hundred such works. Now they are countless. Almost anyone who listens to sound now listens easily no matter what overtone structures the sounds have. We no longer discriminate against noises.

We can also hear any pitch, whether or not it's part of a scale of one temperament or another, occidental or oriental. Sounds formerly considered out of tune are now called microtones. They are part and parcel of modern music.

Some people still object to loud sounds. They're afraid of hurting their ears. Once I had the opportunity to hear a very loud sound (the conclusion of a Zaj performance). I'd been in the audience the evening before. I knew when the sound was coming. I moved close to the loudspeaker from which it was to be heard and sat there for an hour, turning first one ear and then the other toward it. When it stopped, my ears were ringing. The ringing continued through the night, through the next day, and through the next night. Early the following day I made an appointment with an ear specialist. On my way to his office, the ringing seemed to have more or less subsided. The doctor made a thorough examination, said my ears were normal. The disturbance had been temporary. My attitude toward loud sounds has not changed. I shall listen to them whenever I get the chance, keeping perhaps a proper distance.

Our experience of time has changed. We notice brief events that formerly might have escaped our notice and we enjoy very long ones, ones having lengths that would have been considered, say fifteen years ago, intolerable.

Nor are we concerned about how a sound begins, continues, and dies away. During a panel discussion on piano music from the People's Republic of China, Chou Wen-

Chung said that Western musicians formerly insisted that a pitched sound should stay on pitch, not waver from the moment it begins until it ends. Chinese musicians, he said, feel some change in its course in its pitch enlivens a sound, makes it "musical." Nowadays, anyone listens to any sounds, no matter how flexible or inflexible they are with respect to any of their characteristics. We've become attentive to sounds we've never heard before. I was fascinated when Lejaren Hiller described his project to use computer means to make a "fantastic orchestra," to synthesize extraordinary sounds, sounds beginning as though plucked, continuing as from pipes, ending as though bowed.

We're also open-minded about silence. Silence isn't as generally upsetting as it used to be.

And melody. *Klangfarbenmelodie* has not taken the place of *bel canto*. It has extended our realization of what can happen. The same is true of aperiodic rhythm: it includes the possibility of periodic rhythm. Two or more lines composed of sounds can be heard whether they involve known or invented kinds of counterpoint or are just simultaneous (not intervallically controlled). Even if two melodies, one very loud, the other very soft, are played at the same time, we know if we listen carefully, or from another position in space, we'll hear them both.

We can be extremely careful about harmony, as Lou Harrison, La Monte Young, and Ben Johnston are, or we can be, as I often am, extremely careless about harmony. Or we can make do as our orchestras do with grey compromise about which sounds sounded together are harmonious.

Anything goes. However, not everything is attempted. Take the division of a whole into parts. In the 'thirties I was impressed by Schoenberg's insistence on musical structure, but disagreed with his view that tonality was its necessary means. I investigated time-lengths as a more comprehensive means. Using permutation, I made tables of the numbers one through twelve, giving their division into prime numbers. These number-series could be understood either in terms of tonality or time-length or rhythmic structures. The series 1-2-1, which appears in the table for the number 4, can be recognized as an A-B-A structure. It could be expressed tonally or rhythmically (or both). The number 7 has 64 different number-series. Only three of these are A-B-A, namely, 2-3-2, 3-1-3, and 1-5-1. Though some of the others have been exemplified musically, I think many have not. The possibilities increase for the higher numbers. There are 2,048 for the number 12. If we add the possibility of fractions, who knows what musical structures may be discovered? Interesting ones are being found by Elliott Carter and Conlon Nancarrow involving superimposed independent gradual transitions from one tempo to another; those by Nancarrow are particularly interesting. Dealing exclusively with player pianos, he produces extremes of speed that are astonishing and exhilarating.

Many composers no longer make musical structures. Instead they set processes going. A structure is like a piece of furniture, whereas a process is like the weather. In the case of a table, the beginning and end of the whole and each of its parts are known. In the case of weather, though we notice changes in it, we have no clear knowledge of its beginning or ending. At a given moment, we are when we are. The nowmoment.

Were a limit to be set to possible musical processes, a process outside that limit

would surely be discovered. Since processes can include objects (be analogous, that is, to environment), we see there is no limit. For some time now, I have preferred processes to objects for just this reason: processes do not exclude objects. It doesn't work the other way around. Within each object, of course, a lively molecular process is in operation. But if we are to hear it, we must isolate the object in a special chamber. To focus attention, one must ignore all the rest of creation. We have a history of doing precisely that. In changing our minds, therefore, we look for that attitude that is non-exclusive, that can include what we know together with what we do not yet imagine.

There is the question of feelings, whether like emotions they seem to come spontaneously from within, or, like likes and dislikes, they seem to be caused by sense perceptions. In either case, we know that life's more fully lived when we are open to whatever—that life is minimized when we protect ourselves from it. Naturally, we don't set out to kill ourselves. We will continue to "wrestle with the Daimonic" (as M. C. Richards puts it), and a variety of disciplines will continue to be used to open the mind to events beyond its control. But more and more a concern with personal feelings of individuals, even the enlightenment of individuals, will be seen in the larger context of society. We know how to suffer or control our emotions. If not, advice is available. There is a cure for tragedy. The path to self-knowledge has been mapped out by psychiatry, by oriental philosophy, mythology, occult thought, anthroposophy, and astrology. We know all we need to know about Oedipus, Prometheus, and Hamlet. What we are learning is how to be convivial. "Here Comes Everybody." Though the doors will always remain open for the musical expression of personal feelings, what will more and more come through is the expression of the pleasures of conviviality (as in the music of Terry Riley, Steve Reich, and Philip Glass). And beyond that a nonintentional expressivity, a being together of sounds and people (where sounds are sounds and people are people). A walk, so to speak, in the woods of music, or in the world itself.

The difference between closed-mindedness and open-mindedness resembles the difference between the critical and creative faculties, or the difference between information about something (or knowledge even) and that something itself. Christian Wolff found the following, written by Charles Ives, and sent it on to me: "What music is and is to be may be somewhere in the belief of an unknown philosopher of half a century ago who said, 'How can there be any bad music? All music is from heaven. If there is anything bad in it, I put it there—by my implications and limitations. Nature builds the mountains and meadows and man puts in the fences and labels.'" The fences have come down and the labels are being removed. An up-to-date aquarium has all the fish swimming together in one huge tank.

Musical open-mindedness has come about in this century in Europe both West and East, in the Americas, in Japan, Australia, and perhaps New Zealand. It doesn't exist, except perhaps exceptionally, in India, Indonesia, and Africa. (When in traveling around the world with the Dance Company in 1964 we came to India, Merce Cunningham said, "This is the land of the future.") Musical open-mindedness exists in Russia but is not permitted exportation. It is politically excluded in China (though I've heard

tell that sometime in the 'sixties Italy's representatives in China managed to arrange a concert in Peking of the music of Sylvano Bussotti).

The reasons for this musical open-mindedness are several. First of all: the activities, the battles won, by many composers. In this country alone, open-mindedness is implied by the work particularly of Ives, Ruggles, Cowell, and Varèse. Cowell used to tell the story about Ruggles and the Florida class in harmony. The problem of modulating from one key to another "very distant" one was discussed. After an hour, the instructor asked Ruggles how he, Ruggles, would solve the problem. Ruggles said: I wouldn't make a problem out of it; I'd just go from one to the other without any transition.

A second reason for open-mindedness: changes in technology associated with music. Given the tape recorders, synthesizers, sound systems, and computers we have, we could not reasonably have been expected to keep our minds fixed on the music of earlier centuries, even though many of the schools, conservatories, and music critics still do. A third reason for open-mindedness: the interpenetration of cultures formerly separated. In the nineteenth century even Englishmen occupying India were few and far between who took Indian music seriously. Times have changed. At the present time, if a university takes music seriously, it does as Wesleyan University in Connecticut does: it brings together in one school as many different musical cultures of the world as it can afford (music of Africa, of India, of Indonesia, and Japan, together with European music, music of the American Indians, and new electronic music). A fourth reason for open-mindedness: there are more of us and we have many ways of getting together (the telephone, the media, travel by air). If one of us doesn't have an idea that will open the minds of the rest of us, another will. We begin to be keenly aware of the richness and uniqueness of each individual and the natural capacity in each person to open up new possibilities for another. In her recent book, *The Crossing Point*, M. C. Richards tells of her work with retarded children, how it is characterized not just by her helping them, but also by their helping her. Some years ago I was asked to speak to a group of doctors associated with a mental hospital in Connecticut. I had no clear idea in my mind what to say. But as I went down the corridors toward the room where I was to speak, I found myself among people "out of their minds." What had to be said to the doctors became clear: You're sitting on top of a gold mine! Share the wealth with the rest of us! The same is true of our prisons. When Buckminster Fuller did not know whether his wife Anne was to live or not (following an automobile accident), or, if she did live, whether she would be incapacitated or not, it was a letter from a former convict in a California penitentiary on the subject of life, love, and death that gave him consolation. There are untouched resources in children and teen-agers which we do not have because we send them to school; and among the military whom we lose by sending them around the world and beneath its surface to bomb-proof offensive installations; and among the senior citizens whom we have persuaded to leave us in favor of sunshine, fun, and games. We have systematically deprived ourselves of all these people, probably because we didn't want them to bother us while we were doing whatever we were doing. But if there is any experience more than another which conduces to open-mindedness, it is the experience of being bothered by another, of being interrupted by another. "We are study-

ing being interrupted." Say we do not practice any spiritual discipline. The telephone then does it for us. It opens us to the world "outside."

George Herbert Mead said that when one is very young he feels he belongs to one family, not to any other. As he grows older, he belongs to one neighborhood rather than another: later, to one nation rather than another. When he feels no limit to that to which he belongs, he has, Mead said, developed the religious spirit. The open-mindedness among composers (which has affected performers and listeners too) is comparable and kin to the religious spirit. The religious spirit must now become social so that all Mankind is seen as Family, Earth as Home. Music's ancient purpose—to sober and quiet the mind, thus making it susceptible to divine influences—is now to be practiced in relation to the Mind of which through technological extension we all are part, a Mind, these days, confused, disturbed, and split.

Music has already taken steps in this direction, toward social interaction, the non-political togetherness of people.

The Renaissance-honored distinctions between composers, performers, and listeners are no longer everywhere maintained. The blurring of these distinctions has come about for several reasons. First of all: the activities of many composers, particularly Feldman and Wolff, who have made their compositions indeterminate, so that performers, rather than merely doing what they are told to do, have the opportunity to use their own faculties, to make decisions in a field of possibilities, to cooperate, that is, in a particular musical undertaking. Those listening to indeterminate music have been encouraged in their listening, since they have been joined in such music by the composers and performers too.

Secondly, technology has brought about the blurring of the distinctions between composers, performers, and listeners. Just as anyone feels himself capable of taking a photograph by means of a camera, so now and increasingly so in the future anyone, using recording and/or electronic means, feels and will increasingly feel himself capable of making a piece of music, combining in his one person the formerly distinct activities of composer, performer, and listener. However, to combine in one person these several activities is, in effect, to remove from music its social nature. It is the social nature of music, the practice in it of using a number of people doing different things to make it, that distinguishes it from the visual arts, draws it toward theater, and makes it relevant to society, even society outside musical society. The popularity of recordings is unfortunate, not only for musical reasons, but for social reasons: it permits the listener to isolate himself from other people. What is needed is not that the several activities of different people come together in one person, but that the distinctions between the roles of different people be blurred, so that they themselves may come together.

A third cause for the blurring of the distinctions between composers, performers, and listeners: the interpenetration of cultures formerly separated. There is no longer an essential difference between some serious music and some popular music—or, you may say, a bridge exists between them: their common use of the same sound systems, the same microphones, amplifiers, and loudspeakers. In the cases of much popular and some oriental musics, the distinctions between composers and performers were never very

clear. Notation, as Busoni said it did, did not stand between musician and music. People simply came together and made music. Improvisation. It can take place, so to speak, strictly, as within the *raga* and *tala* limitations of Indian music, or it can take place freely, merely in a space of time, as sounds do environmentally, whether in the country or in the cities. Just as aperiodic rhythm can include periodic rhythm, just as process can include object, so free improvisations can include strict ones, can even include compositions. The Jam Session. The Musicircus.

In 1974 Richard K. Winslow suggested changing my instrumental parts for *Etcetera* so that they would read Bowed Instrument, Wind Instrument, Double Reed, Single Reed, rather than Violin, Flute, Oboe, Clarinet, thus bringing to parts for pitched instruments something of the vagueness and freedom conventionally given to parts for percussion players. (If you don't have the percussion instrument called for, you substitute something else.) Oriental and occidental instruments together in ensemble. A duet between tuba and sitar! This is possible only when the actions to be made are not on the ground special to either, but on the ground common to both. Since *Etcetera*, I have written *Score with Parts: Twelve Haiku* and *Renga*, graphic notations in which the parts are differentiated only by numbers. A given part may be played on any instrument.

With our increase in population there has come about a great increase in musical activity. Formerly concerts of new music were few and far between. Now there is more going on than you can shake a stick at. So that it always surprises me when I run into the thought there's nothing further, nothing new, to do in music; though I remember feeling that way in the early 'thirties: I was full of admiration for what had been accomplished; I had not yet gotten to work. For the most part, music that's now being made in New York, the new music, that is, is music I want to hear, though too often I cannot for I'm busy elsewhere. Audiences are large, generally filling the spaces used. And more and more, as in the evenings in New York known as "Sounds out of Silent Spaces," evenings with a cooperative music-making group founded by Philip Corner, the audiences themselves participate.

We can say that this blurring of the distinctions between composers, performers, and listeners is evidence of an ongoing change in society, not only in the structure of society, but in the feelings that people have for one another. Fear, guilt, and greed associated with hierarchical societies are giving way to mutual confidence, a sense of common well-being, and a desire to share with another whatever one person happens to have or to do. However, these changed social feelings which characterize many evenings of new music do not characterize the society as a whole.

Revolution remains our proper concern. But instead of planning it, or stopping what we're doing in order to do it, it may be that we are at all times in it. I quote from M. C. Richards' book, *The Crossing Point:* "Instead of revolution being considered exclusively as an attack from outside upon an established form, it is being considered as a potential resource—an art of transformation voluntarily undertaken from within. Revolution arm in arm with evolution, creating a balance which is neither rigid nor explosive. Perhaps we will learn to relinquish voluntarily our patterns of power and subservience, and work together for organic change."

At the beginning of the *Essay on Civil Disobedience*, Thoreau has this quotation: "That government is best which governs not at all." He adds: "And when men are prepared for it, that will be the kind of government which they will have." Many musicians are ready. We now have many musical examples of the practicality of anarchy. Music with indeterminate parts, no fixed relation of them (no score). Music without notation. Our rehearsals are not conducted. We use that time to make our setups: to make sure that everything that is needed by any of the musicians is there, that everything is in good working order. Musicians can do without government. Like ripe fruit (I refer to the metaphor at the end of Thoreau's *Essay*), they have dropped away from the tree.

Less anarchic kinds of music give examples of less anarchic states of society. The masterpieces of Western music exemplify monarchies and dictatorships. Composer and conductor: king and prime minister. By making musical situations which are analogies to desirable social circumstances which we do not yet have, we make music suggestive and relevant to the serious questions which face Mankind.

Some politically concerned composers do not so much exemplify in their work the desired changes in society as they use their music as propaganda for such changes or as criticism of the society as it continues insufficiently changed. This necessitates the use of words. Sounds by themselves do not put messages across. And when they do not use words, politically concerned composers tend to revert to nineteenth-century musical practices. This is enforced in both Russia and China. And encouraged in England by Cornelius Cardew and the members of the Scratch Orchestra. They study the pronouncements on art by Mao Tse-tung and apply them as literally and legalistically as they can. They therefore have criticized the politically concerned music of Frederick Rjewski and Christian Wolff, simply because new ways to make music have been discovered by both of these composers. Rjewski's works (and some of Garrett List's, too) flow like the rapids of a river: they suggest irresistible change. Rjewski and List have found virtuosi who vocalize rapidly and over long periods of time uninterruptedly (not seeming to take any time off to breathe); Wolff's works invariably reveal to both performers and listeners energy resources they have of which they hadn't been aware and put those energies intelligently to work.

Implicit in the use of words (when messages are put across) are training, government, enforcement, and finally the military. Thoreau said that hearing a sentence he heard feet marching. Syntax, N. O. Brown told me, is the arrangement of the army. The pen has formerly been considered more powerful than the sword. American shame and spiritual frustration result at least in part from the fact that even though the country's best pens and best voices throughout our history have been raised in protest against our government's actions, and even though thorough plans have been clearly proposed for the improvement of environment and the well-being of all people—not just Americans, but all people—the American powers that be remain deaf and blind. We know from Buckminster Fuller and many others that the continued use of fossil fuels is against both environment and the lives of people in it. We should use above-earth energy sources exclusively: sun, wind, tides, and algae. The nations don't seem to know this. National and international triumphs, whether of the USA or other countries, still have to do

with the foolish exploitation of below-earth resources. Fuller did not smile when I asked him about atomic energy. Inevitable in it is the slow but steady raising of Earth's temperature to a heat in which life would be unendurable (see Robert L. Heilbroner: *An Inquiry into the Human Prospect*). Since words, when they communicate, have no effect, it dawns on us that we need a society in which communication is not practiced, in which words become nonsense as they do between lovers, in which words become what they originally were: trees and stars and the rest of primeval environment. The demilitarization of language: a serious musical concern.

When I was commissioned by the Boston Symphony Orchestra to write a work in celebration of the American Bicentennial, Seiji Ozawa said, "Make it easy!" Our institutions, not just the musical ones, are incapable of hard work. Time is counted to the second and limited. The goal of an individual within an institution has nothing to do with the work to be done or with the state of his mind. It has to do with the payment to be received. A necessary aspect of the immediate future, not just in the field of environmental recovery, is work, hard work, and no end to it. Much of my music since 1974 is extremely difficult to play (the *Etudes Australes* for the pianist Grete Sultan; the *Freeman Etudes* for the violinist Paul Zukofsky). The overcoming of difficulties. Doing the impossible. Grete Sultan was enthusiastic at the prospect of work. When I told the composer Garrett List what I was up to, there was liveliness in his eyes and a smile of recognition. He also was at work on something having the nature of work. And a recent long work by Christian Wolff is called *Exercises*.

Tom Howell at the University of Illinois inspired his students to explore the playing of two or more notes at a time on a single wind instrument. In the books you can play only one at a time: His teaching produced work. Multiphonics.

As a pianist, David Tudor laboriously developed the ability, not yet approached by others, to give each attack in a rapid succession of many its own dynamic character. He took the principle underlying *Klangfarbenmelodie* (a succession of different timbres) and applied it to the relation between himself and his instrument: differences of energy, of distance and speed of attack, an extension of the understanding of the mechanism of keys, hammers, strings. Nowadays, Tudor rarely plays the piano. His work is in the field of electronics, often in relation to video, and often in collaboration with others. He invents components and sound systems of great originality. He solders and constructs them. He keeps abreast of the developments throughout the world in the field of electronics. He makes new loudspeakers free of the constriction of high fidelity.

There is endless work to be done in the field of electronic music. And many people at work: David Behrman, Gordon Mumma, Robert Ashley, Alvin Lucier, Phill Niblock, to name five. And in the field of video and visual technology (composers also have eyes): Lowell Cross, Tony Martin, Nam June Paik, to name three. And in the field of computer music (shortly everyone, whether he's a musician or not, will have a computer in his pocket): Joel Chadabe, Giuseppe Englaert, Jean-Claude Risset, Lejaren Hiller, Max Mathews, John Chowning, Charles Dodge, Emmanuel Ghent, to name eight.

As I look back over my own work, I observe that more often than not I have had

other people in mind. I had Robert Fizdale and Arthur Gold in mind when I wrote the *Book of Music for Two Pianos*. The *Sonatas and Interludes* for prepared piano is a portrait of Maro Ajemian. Beginning with my *Music of Changes*, and continuing through *Variations VI*, my music always had David Tudor in mind. I notice now that many composers in their work have not a person but a place (environment) in mind. This is true of Pauline Oliveros' work, *In Memoriam Nikola Tesla*. The concern with place characterizes the work of Alison Knowles, whether she is working with Yoshimasa Wada or Annea Lockwood. Music becomes something to visit. Or a shrine, as in the *Eternal Music* of La Monte Young. An environment to go through (as in a work by Maryanne Amacher, or Max Neuhaus, or Liz Phillips). At Wesleyan University I met two young men studying with Alvin Lucier, Ron Goldman and Nicolas Collins. They gave an electronic concert in the tunnels below the new Arts Center in Middletown. By walking through the tunnels one passed through nodes and noticed (as one does in Oliveros' work) sympathetic vibrations arising in the building and its furniture. There's music to be made in geodesic domes, on unused subway platforms, in laundromats, in fields, forests, and in cities conceived as Robert Moran conceives them as immense concert halls.

Sympathetic vibrations. Suggestiveness and work. I have heard electronic components go into operation even though they were not plugged into the system. I said to someone who understood electronics and who was helping me, "Don't you think that's strange? It's not connected but it's working." His comment: "It's so close to the others, I would find it stranger if it didn't start working."

People and places. Musical theater. The Happening. The longest one we've ever had (Watergate) is still going on (at least in our minds). It is comparable to Greek or Noh drama. I attended a very short happening (not more than two minutes). It was performed in the window of a coffee shop in Soho by Ralston Farina, a young man who changed his name when he noticed two boxes of cereal. The audience with coats on stood in the street outside. His work was enigmatic and invigorating.

People and places: ritual. People and places: food. I remember attending a Potlatch near Anacortes, Washington. For days and nights people under the same roof sleeping, eating, cooking, dancing, singing. Changing the USA so that it becomes American Indian again. Margaret Mead. Bob Wilson. Jerome Rothenberg. David McAllester. Avery Jimerson of the Seneca Tribe.

Buckminster Fuller's *Synergetics* (876 pages) was published in 1975. It is no doubt inspiring a new music.

Merce Cunningham's dancing is also inspiring. Through the years Cunningham's faithfulness to the principle of work has never wavered. His dance technique itself is not fixed. It is a continuing series of discoveries of what a human body can do when it moves in and through space. Sometimes he appears as someone who has an insatiable appetite for dance; at other times he seems like dance's slave. James Rosenberg, a young Berkeley, California, poet whose work I admire, makes of himself, as I advised him, a slave to poetry. He is inspired, as I am, by Jackson MacLow's example of untiring devotion. I recall a performance by Charlemagne Palestine that was reminiscent of the body-art of Vito Acconci. Palestine shouted a vocal music at high amplitude while con-

tinuously running at high speed through the audience for a long time up to the point of physical exhaustion.

The first part of a new text by Norman O. Brown is on work. It was his reaction, I believe, to the somewhat complacent, though religious, spirit of the young in California communes. The willingness to settle for survival. Brown's concern is how to make a new civilization. Work is the first chapter. Ideas are in the air. In our polluted air there is the idea that we must get to work. Somehow, recently, in New York and in other cities too, the air seems less polluted than it was. Work has begun.

For a musical work to be implemented in China, it must be proposed not by an individual but by a team. The necessity for teamwork in music has been emphasized by Pierre Boulez in a Canadian interview with him about the research institute, IRCAM, now formed at the Centre Pompidou in Paris. The evenings with Philip Corner, Emily Derr, Andrew Franck, Dan Goode, William Hellerman, Tom Johnson, Alison Knowles, Dika Newlin, Carole Weber, Julie Winter, and the participating "audience" are teamwork. They are learning how to work together without one person's telling another what to do, and these evenings are open to strangers. How many people can work together happily, not just efficiently—happily and unselfishly? A serious question which the future of music will help to answer.

When I received the announcement of the evenings with Philip Corner and his friends, I noticed that no names were given, not even Philip Corner's. However, the announcement was not typeset; it was handwritten. And I recognized Philip Corner's handwriting. The omission of names. Anonymity. People going underground. In order, like Duchamp, to get the work done that is to be done.

People frequently ask me what my definition of music is. This is it. It is work. That is my conclusion.

However, just as I wrote it, the doorbell rang. It was the postman bringing me a present from William McNaughton, his editing of *Chinese Literature* (an anthology from the earliest times to the present day). The book includes many of McNaughton's own translations. On the endpaper of my copy is a dedication to me followed by fourteen Chinese characters, a reference to page 121, and McNaughton's signature. I turned to page 121 and read the following from his translation of *Chuang-tzu's Book*: "Everybody knows that useful is useful, but nobody knows that useless is useful, too." This is from Chapter 4 of *Chuang-tzu's Book*. A tree is described that gives a great deal of shade. It was very old and had never been cut down simply because its wood was considered to be of no use to anyone.

I want to tell the story of Thoreau and his setting fire to the woods. I think it is relevant to the practice of music in the present world situation, and it may suggest actions to be taken as we move into the future.

First of all, he didn't mean to set the fire. (He was broiling fish he had caught.) Once it was beyond his control, he ran over two miles unsuccessfully for help. Since there was nothing he could do alone he walked to Fair Haven Cliff, climbed to the highest rock, and sat down upon it to observe the progress of the flames. It was a glorious spectacle and he was the only one there to see it. From that height he heard bells in the village

sounding alarm. Until then he had felt guilty, but knowing that help was coming his attitude changed. He said to himself: "Who are these men who are said to be the owners of these woods, and how am I related to them? I have set fire to the forest, but I have done nothing wrong therein, and it is as if the lightning had done it. These flames are but consuming their natural food."

When the townsmen arrived to fight the fire, Thoreau joined them. It took several hours to subdue the flames. Over one hundred acres were burned. Thoreau noticed that the villagers were generally elated, thankful for the opportunity that had given them so much sport. The only unhappy ones were those whose property had been destroyed. However, one of the owners was obliged to ask Thoreau the shortest way home, even though the path went through the owner's own land.

Subsequently, Thoreau met a fellow who was poor, miserable, often drunk, worthless (a burden to society). However, more than any other, this fellow was skillful in the burning of brush. Observing his methods and adding his own insights, Thoreau set down a procedure for successfully fighting fires. He also listened to the music a fire makes, roaring and crackling: "You sometimes hear it on a small scale in the log on the hearth."

Having heard the music fire makes and having discussed his fire-fighting method with one of his friends, Thoreau went farther: suggesting that along with firemen there be a band of musicians playing instruments to revive the energies of weary firemen and to cheer up those who were not yet exhausted.

Finally he said that fire is not only disadvantage. "It is without doubt an advantage on the whole. It sweeps and ventilates the forest floor, and makes it clear and clean. It is nature's broom. . . . Thus, in the course of two or three years new huckleberry fields are created for birds and for men."

Emerson said that Thoreau could have been a great leader of men, but that he ended up simply as the captain of huckleberry-picking-parties for children. But Thoreau's writing determined the actions of Martin Luther King, Jr., and Gandhi, and the Danes in their light-hearted resistance to Hitler's invasion. India. Nonviolence.

The useless tree that gave so much shade. The usefulness of the useless is good news for artists. For art serves no material purpose. It has to do with changing minds and spirits. The minds and spirits of people are changing. Not only in New York, but everywhere. It is time to give a concert of modern music in Africa. The change is not disruptive. It is cheerful.

About the Author

His teacher, Arnold Schoenberg, said John Cage was "not a composer but an inventor of genius." Composer, author, and philosopher, John Cage was born in Los Angeles in 1912 and by the age of 37 had been recognized by the American Academy of Arts and Letters for having extended the boundaries of music. He was elected to the American Academy of Arts and Sciences in 1978, and in 1982, the French government awarded Cage its highest honor for distinguished contribution to cultural life, Commandeur de l'Ordre des Arts et des Lettres. Cage composed hundreds of musical works in his career, including the well-known "4'33"" and his pieces for prepared piano; many of his compositions depend on chance procedures for their structure and performance. Cage was also an author, and his book *Silence* was described by John Rockwell in the *New York Times* as "the most influential conduit of Oriental thought and religious ideas into the artistic vanguard—not just in music but in dance, art and poetry as well." John Cage's books, published by Wesleyan, are *Silence* (1961), *A Year from Monday* (1967), *M* (1973), *Empty Words* (1979), which Cage also regarded as a performance piece, and *X* (1983). John Cage died in 1992 at the age of 79.

Designed by Raymond M. Grimaila

The text was composed by P & M Typesetting, Incorporated in Linotype Caledonia with Optima display.

Empty Words was typewritten by the author using an IBM Selectric II with two elements, Courier 12, roman and italic.

Writing for the Second Time Through Finnegans Wake was set in Monotype Bembo at the Stinehour Press. The typography was designed by Freeman Keith, the position of punctuation designed and realized by John Cage and Alison Knowles.

Except for *Preface to "Lecture on the Weather," The Future of Music,* and *Writing for the Second Time Through Finnegans Wake,* the typography was composed with the aid of I Ching chance operations.